CHARLES ALSTON

Alvia J. Wardlaw

THE DAVID C. DRISKELL SERIES OF AFRICAN AMERICAN ART: VOLUME VI

Pomegranate

SAN FRANCISCO

Published by Pomegranate Communications, Inc.

Box 808022, Petaluma CA 94975

800 227 1428 www.pomegranate.com

Pomegranate Europe Ltd.

Unit 1, Heathcote Business Centre

Hurlbutt Road, Warwick

Warwickshire CV34 6TD, UK

[+44] 0 1926 430111

Library of Congress Cataloging–in–Publication Data

Wardlaw, Alvia J.

 Charles Alston / Alvia J. Wardlaw.

 p. cm.—(The David C. Driskell series of African American art ; v. 6)

 Includes index.

 ISBN-13: 978-0-7649-3766-8

 1. Alston, Charles Henry, 1907–1977—Criticism and interpretation. 2. African American artists—New York (State)—New York. I. Title.

 N6537.A467W37 2007

 759.13—dc22

 2006030139

Pomegranate Catalog No. A119

Design by Lynn Bell, Monroe Street Studios, Santa Rosa, California

Cover image: Charles Alston, *Adam and Eve,* c. 1945, oil on canvas, 40 x 30 in. Courtesy of Michael Rosenfeld Gallery, LLC, New York, NY.

Back cover image: Charles Alston, *Confrontation,* 1969, oil on canvas, 36 x 40 in. Courtesy of Michael Rosenfeld Gallery, LLC, New York, NY.

Printed in China

16 15 14 13 12 11 10 09 08 07 10 9 8 7 6 5 4 3 2 1

CONTENTS

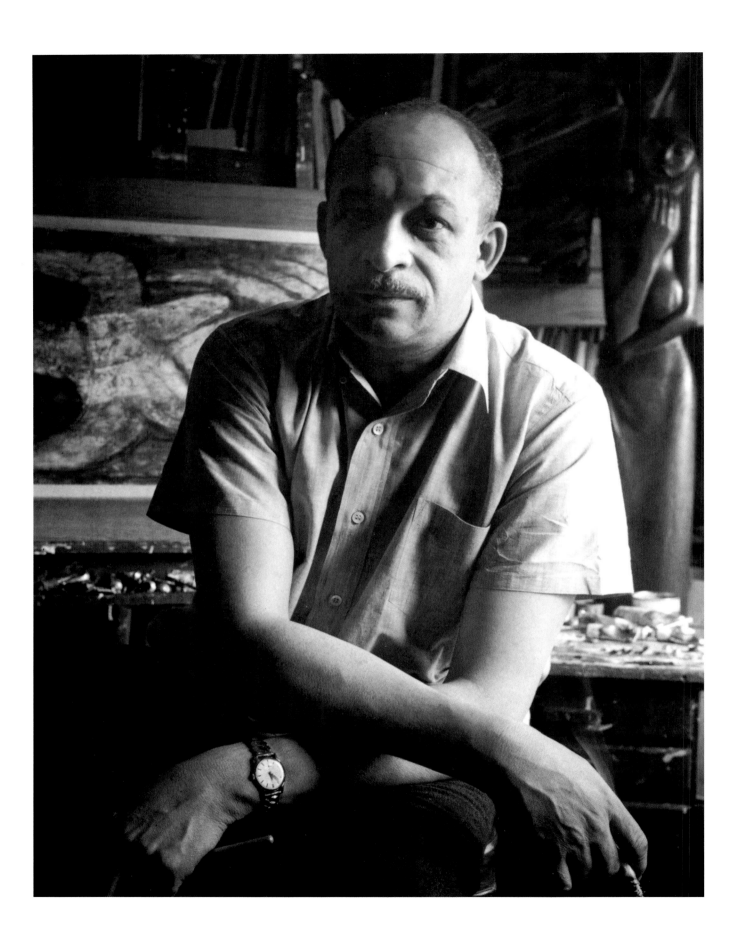

FOREWORD

*T*hroughout the years, many African American artists have made significant contributions to the nation's visual arts without seeing their achievements credited. They have participated in important art movements minus the benefit of patronage and often without even an acknowledgment of their presence. Within these ranks of unsung artists belongs Charles Alston.

Alston came to the attention of the public at a time when only a few artists of color had broken into the "mainstream" of American art. His uncanny ability to make friends in the right places, along with his knowledge of the field, enabled him to mix and mingle with the best in the New York art world, in a way that enhanced his standing—among blacks and whites—as an artist of promise. Moreover, he held on to the mores and ardent principles of his southern upbringing long after he arrived in Harlem, into his adult years as an aspiring artist in the 1920s, during the burgeoning of the New Negro movement. He witnessed the Great Migration of African Americans to northern cities, particularly New York, lured by the promise of better employment and a good education. The chance to attend one of the best high schools in the city and then continue his education at an Ivy League institution was a dream come true—one unlike any he could have hoped for in the South.

Like his cousin by marriage Romare Bearden, Alston was born in Charlotte, North Carolina, "the queen city," in 1907, four years ahead of Bearden. Both would later migrate north with their respective families and eventually become active visual artists in Harlem, the black city within New York City. The connections between these two young artists were destined to grow over the years, particularly in the period of the Harlem Renaissance. Their careers as artists would flower concurrently and mature in parallel, even though Alston would benefit less than Bearden from widespread patronage in his lifetime. Both painters would later move their artistry beyond easel painting to murals, with Alston being sought out to execute several major mural assignments in New York and Los Angeles, among others.

Alston had decided early on in his life that art would be his calling, and he pursued the profession with diligence and dedication for more than five decades. His academic training at Columbia University prepared him well for the rigors ahead, in both art practice and art administration. But it would be his interaction with fellow artists—Bearden; Jacob Lawrence, who was Alston's most acclaimed student; and, later in life, members of the Spiral group—that would allow him to situate his art within an avowedly black aesthetic, one that remained thereafter the focus of his creative production.

Facing page: Charles Alston. Photograph courtesy of Aida Bearden Winters.

A master draftsman and keen observer of life, Alston initially chose to see his subjects through the eyes of a social realist. After several years of painting in that vein, he shifted to various forms of abstraction, in which modern elements of figuration were evident. Because Alston remained at heart a figurative artist at a time when forms of abstraction and action painting dominated the American art scene, particularly in the 1950s, some critics accused him of consciously grounding his work in an outdated format. Alston rejected this assertion. He found himself at odds also with a younger cadre of black artists who insisted that his abstract subject matter made him a model more for mainstream artists than for themselves. Yet, in spite of their ongoing dialogue, Alston held on to his own high standards in art and provided artists of color—as well as the diverse artists he taught at the Art Students League—with wise counsel and a genuinely sensitive, modernist foundation on which to base their art.

Alston's skill as a teacher was apparent even in his early association with young artists in Harlem, many of whom went on to national and international acclaim. As previously noted, Jacob Lawrence stands out as the most distinguished painter to have trained under Alston's tutelage. But students from his classes at Columbia University, along with the circle of friends who gathered around him at "306"—the renowned building on 141st Street where many artists and intellects congregated to soak up Alston's advice about art and his lessons on life—left him knowing that they were experiencing an important, indeed a select, moment in history. They were being inculcated with the wisdom of a sage, whose knowledge of the art world extended beyond New York City and referenced the beginnings of an emerging black American aesthetic.

Alston learned the lessons of cultural diplomacy well by becoming marginally accepted into the mainstream of the American art world. He knew that he was being called upon by the art establishment to represent "the black artist." By 1950, his work was being collected by major institutions, such as the Metropolitan Museum of Art and the Whitney Museum of American Art. His name became increasingly known in art circles across the country, particularly since his work had appeared in the Harmon Foundation's nationwide exhibition programs. In the last two decades of his life, Alston began to wield influence as an artist who was highly regarded across racial lines.

His service on distinguished boards in the city of New York, at a time when racism pervaded almost every public institution in existence, made him a role model for cross-cultural understanding. As author Alvia Wardlaw notes, Alston became the first black supervisor in the WPA Federal Art Project in 1935. This appointment represented a significant step forward, even for the mildly progressive art scene in liberal New York City.

Alston's entry into the world of the muralist was buttressed by his competency as a fine arts administrator and by his having proven, beyond reasonable doubt, that he was one of the most gifted artists on the New York scene. His celebrated mural project at Harlem Hospital, in which he traced the evolution of modern medicine from an African setting into the twentieth century, was highly praised by critics and observers of contemporary art in the 1930s. Inspired by the fresh synthesis of painting Aaron Douglas had brought to the development of the mural arts, particularly in the black academy, Alston's murals set the stage for other African American artists of

note—Hale Woodruff, Charles White, Lois M. Jones, James A. Porter, and John Biggers, among others—being called upon to showcase their work. Many of these artists went on to create numerous mural paintings on major buildings at black colleges around the nation.

The most prominent aspect of Alston's artistry is the attention he paid to painting the human figure. His observations of Harlem's vibrant nightlife in the 1930s helped him see the joyous aspect of living that had been the subject of other artists, novelists, poets, and musicians in the renaissance movement. AfriCobra cofounder Jeff Donaldson has written about the aura and mesmerizing atmosphere of 306, where Alston created such seminal works as *Girl in a Red Dress* and *Man Seated with Travel Bag*. Jacob Lawrence would later seize upon such themes with his own *Migration* and *The Travellers*, thereby keeping alive the figural tradition that had been a trademark of Alston's early work.

Alston's mature style in painting came to reflect a distinct combination of cubism with a classically based form of figuration, highlighting his serious study of black African sculpture. His early exposure to what was then referred to as the tribal arts of Africa made a lasting impression on the young artist, who would later incorporate elements of African iconography into his mural works. Similarly, Aaron Douglas had used African art in his celebrated *Aspects of Negro Life* murals at the 135th Street Library, in close proximity to Harlem Hospital, an act that did not go unnoticed by Alston. He would later comment on the respect he had for Douglas as a pioneering black artist who helped change our unfounded notions of "primitivism."

Alston's modernist form of figuration—heavily reliant on revised aspects of cubism, combined with a fresh look at the iconography of African art—became the signature style of the artist's work in the 1950s. It was in this period that the mother-and-child theme and family scenes became the visual trademark by which one could readily identify an Alston painting. Occasionally he used overt forms of abstraction as dominant elements in his work. At this time he also began using flatly placed geometric patterns of color in various planar relationships throughout each composition. With an overlay of defining lines, usually rendered in white, Alston brought concise definition to abstract forms that introduced familial compositions. In *Family*, which Wardlaw calls Alston's most widely known work, the ideal family of father, mother, son, and daughter is arranged in the manner of a family portrait. Only the daughter strikes a pose that does not conform with the usual straightforward look into the camera. The flatly painted planes of each segment of the composition register first as synthetic cubism, with superimposed white lines delineating each figure. When interviewed by Adolphus Ealey in 1973 regarding his work in the Barnett-Aden Collection, Alston stated that some things evoked feelings of abstraction, while others were figural. This seems to have been how he produced much of his work after 1950.

Standing halfway between these two prevailing artistic styles, one grounded in a modern approach to cubism, the other visually akin to social realism, Alston astutely charted his way as an exhibiting artist whose work was in demand at principal museums and galleries around the nation. As early as 1933, he was among a select group of black artists to have works exhibited at the High Museum of Art in Atlanta, the Baltimore Museum of Art, the Museum of Modern Art, and the

Pennsylvania Academy of the Fine Arts, among other venues. In the 1950s his paintings were exhibited frequently at a number of prestigious New York galleries, often resulting in purchases from major museums such as the Metropolitan, the Whitney, and the Butler Institute of American Art in Youngstown, Ohio.

Not confined to one direction in painting, Alston allowed the form that he saw emerging in his work through color and line to become the intuitive plan by which numerous subjects came to life. Even when he painted figures without facial features, as he often did, he had poignant stories to tell that reinforced the notion that black people remained largely faceless and indeed nameless to the majority culture. He frequently felt conflicted about what he idealized in painting and what he saw happening in the real world. He abhorred the clichés mouthed by liberal whites who supported black causes only when forced to do so. Yet Alston seldom yielded to the view that art should be politically based, and he remained an optimist even in adversity. Although he created a number of editorial cartoons in the 1940s that endorsed civil rights for all people and that encouraged black participation in the war effort (the latter for the Office of War Information), he saw himself at that time as principally a commercial artist, not a propagandist.

After serving for a brief period in the United States Army in 1942–1944, Alston returned to civilian life revitalized and determined to pursue his artistry, not so much as a commercial artist but as a painter, able to set his own creative agenda. This he accomplished with consummate skill while garnering a number of firsts along the way, all of which furthered his efforts to change the face of art in America.

At the time of his death in 1977, Charles Alston had lived a rich and comprehensive life. His steadfast dedication to his profession, as teacher and artist, served as a model to many and enabled others to see how art enhanced their own lives. An unsung master of the craft of painting, Alston is finally, three decades after his death, receiving the credit that should have come in his lifetime.

—DAVID C. DRISKELL

ACKNOWLEDGMENTS

*W*orking on this project to document the important role that Charles Alston played in African American art history was indeed an honor and a great journey of discovery for me. I was only halfway through my research when I realized that the work Alston did was so much more than what most people knew. His involvement with the Harlem Renaissance was a pivotal moment in American cultural history, and his own creative efforts impacted an entire century and beyond.

I would like to thank, first and foremost, artist and scholar David Driskell for giving me the opportunity to express my interpretation of Alston as a man and as an artist. I am honored by his trust in my abilities to write this biography, which I hope will be one of many works to come that will contribute to the knowledge of this great artist and his contemporaries. David Driskell remains an inspiration for all of us in the field of African American art, and this series is a testimony to his groundbreaking work.

To publisher Katie Burke and associate publisher Elaine Graalfs of Pomegranate, I owe endless thanks for their continuous guidance of this publication during a demanding period of my life. I will always be grateful for their insight, their expertise, and their thorough knowledge of the field.

I am particularly grateful for all the images that were provided by collectors and friends of the artist, as well as for their personal contributions and knowledge of key works. I must express special appreciation to Bill Hodges and Michael Rosenfeld for participating in this project. I am indebted to Larry Randall for his work with the Alston family and for introducing me to Mrs. Aida Bearden Winters, Alston's sister, who was a delight to meet. She generously shared her memories of her brother. I am especially thankful to Adele Logan Alexander for spending an afternoon with me, generously reflecting on and interpreting her uncle's art and life. Her family was also exceedingly generous in lending works to be photographed for the project. To Harmon and Harriet Kelley, I offer my thanks for their generosity as collectors. Special thanks go to Harriet for sharing her conversation with Jacob Lawrence and his knowledge of Alston. To Elliot Perry, thanks for your vision.

I could not have completed this work without the support and work of colleagues, friends, and other scholars. Dr. Peter C. Marzio, director of the Museum of Fine Arts, Houston, encouraged me from this project's inception. My curatorial assistant, M'Kina Tapscott, was particularly helpful in researching the Harlem Hospital murals. Bernadette Steward, of the University Museum at Texas Southern University, shepherded me through the first version of the text and footnotes, and to her I extend enormous thanks. I am especially grateful for her dedication to the book and her ongoing help in locating images. Lucille Oliver aided with her proofing and editing talents. Artists George Ford and Jean Lacy provided important insight on Alston's career as a teacher. I am indebted

to Lemoine Pierce for her rigorous research on Alston published in *The International Review of African American Art*. Her experience with so many aspects of Alston's life inspired me to add in a meaningful way to the work that she had completed. Similarly, I am truly indebted to Gylbert Garvin Coker, whose watershed publication on Alston led the way for all of us to further our research. Corinne Jennings, director of Kenkeleba Gallery, had the vision, as she so often does, to document in depth individual contributors to African American culture. Kenkeleba's exhibition catalog on Alston has remained, since 1994, the only authoritative and comprehensive resource on the artist, and for this I am deeply grateful. The book continues to offer important signposts regarding Alston's life, making the work of those of us who follow much easier.

As I stated earlier, halfway through my research it hit me that Alston deserves many publications highlighting the different aspects of his life and career: his extraordinary family, including his gifted wife; his work as a graphic artist in New York; his circle of friends critical to the development of modern art in America; his sculpture; his evolution as a painter of abstract works; his dedication to public art; his dedication to the causes of his people. Each of these topics and many others demand specific attention. Alston was a man who led an incredibly rich life and, through it all, enriched us with his talent. I hope that he and other artists from his generation will continue to be studied in even greater depth. It is for this reason that the David C. Driskell Series of African American Art, published by Pomegranate Communications, is so valuable and so timely. Such a body of publications provides easy access to information on leading—but often poorly documented —African American artists to both scholars and the general public. It is so important to have this information available for the generations to come.

Finally, I am eternally grateful to my entire family for their endless support of my endeavors in the field. It is through the legacy of my family, and through their friendship with many artists—including Hale Woodruff and John Biggers—that I came to know the art of the great Charles Alston. To my sister and brother-in-law, Joy and Darrell Fitzgerald, thanks for your encouragement and for allowing me to use your home in Atlanta as my "research central station" away from Houston. To my father, Alvin H. Wardlaw, who read and enjoyed each chapter of this book and gave me his immediate and enthusiastic feedback, just as my mother, the late Virginia Cage Wardlaw, would have done, I am, as always, endlessly thankful. To my son Mani Jasiri Short: thank you for the constant inquiry and debate. And to my granddaughter, Nela Sinclair Short: this work is for you.

INTRODUCTION

*T*he story of artist Charles Alston cannot be fully told without examining the story of black culture in New York during the twentieth century. His life reads like an intricately woven tale of urban Afro-Americana. Born in North Carolina and raised in New York City, Charles "Spinky" Alston was one of the many black artists for whom Manhattan, and particularly Harlem, served as a muse. Unlike his famous student Jacob Lawrence, Alston did not rise to dramatic prominence; rather, his career was defined by his expansive view of the art world, his solid experience as a teacher who had the innate ability to inspire others, and his never-ending drive to explore through his own art. He was a bridge builder, one of a group of artists who shared resources, exchanged ideas, and self-lessly supported one another, celebrating together the richness of African American culture. He left to New York both a legacy of great public art and an organizational model through which artists could work together effectively to create change within the art establishment.

Hale Woodruff arranged for me to meet Charles Alston in 1970 when I was working on a major paper for my master's degree at New York University's Institute of Fine Arts. I remember Alston as a big man who had an ease about him that, in turn, put me at ease. He directed me to numerous sources to find information on his murals and encouraged me in my research efforts. Little did I know that thirty years later I would once again be writing about Alston and the complexity of his life and work.

As we celebrate the one-hundredth anniversary of Alston's birth and as the art world continues to examine contributions of African American artists to world culture, it is important to place in context the life and work of such an accomplished individual, one who was at once a teacher, a trailblazer (and consequently often in the lonely position of being "the first Negro to . . ."), and ultimately a creative spirit who did not hesitate to expand his artistic horizons through the exploration of a new medium, style, or technique.

Too often in the twenty-first century many rush to "brand" art movements and aesthetic history with oversimplified cultural sound bites and visual vignettes. A new generation of African Americans and gentrification "pioneers" is seeking to "brand" Harlem, to put it in a bottle as a fragrance or on a T-shirt, as if either were possible. The essence of Harlem is in her complexity—mirrored clearly in the life and art of Charles Henry Alston. Just as branding Harlem is an act of futility, so is reducing Alston to a formulaic description.

Anyone who knew him must remember his keen intelligence evident in his art, his publications and personal correspondence, and his repartee. He had a self-confidence that enabled him to move through multiple realities while always maintaining his inner core. His life was filled with subtleties and ironic twists and contrasts, and he navigated his way through them on an urban island composed of an uptown and downtown defined by invisible lines of cultural demarcation.

He was able to connect the dots to make sense of it all. He embraced the contrasts of his life, thriving equally on the Manhattan cocktail parties downtown and the soul food spread (that *he* cooked) uptown; the rarified air of the midtown New York art world and the hardscrabble lives of so many who walked by him on 125th Street; his deeply rooted life as a black bourgeois and his joyous late-night hunts for music, food, and spirited conversation. How many times during his lifetime did Alston encounter people who thought him white and let slip revealing comments about race? What wisdom did he gain from these experiences? His speaking voice contained an everyman type of New York energy, and the unmistakable self-assurance of the black intelligentsia. It flowed forth in interviews, reflecting an urban savvy gained from years of passing through turnstiles, hopping trains, grabbing coffee or a drink with friends, catching a conversation with his neighbor in the elevator or vestibule of his apartment building, moving with the city. The language and oratorical skills handed down from his father shone in his writing, and his father seems present too in Alston's political stance, both fiercely independent and thoroughly considered. Alston could take the lead in demanding that black employees be hired at restaurants and stores on 125th Street, while refusing to participate in exhibitions that featured only black artists, so-called "Negro exhibitions." He consciously refused to be compartmentalized in the art that he made and the life that he lived. His careful decipherment of American cultural traditions and challenges, and social and aesthetic issues, ultimately reflects the same fervor and independence that enabled him always to work, as he said, "from the heart." Watching him blaze his path so well teaches us all that contrasts in life can be good, that significant lessons may be learned from situations filled with contradiction, and that each of us has the power to create our own complex universe.

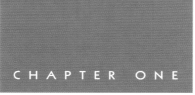

ENDURING ROOTS

A FATHER'S LEGACY

*B*orn in Charlotte, North Carolina, on November 28, 1907, to Reverend Primus Priss Alston and Anna Elizabeth Miller Alston, Charles Henry Alston was the youngest of five children. His father, a prominent minister, had founded St. Michael's Episcopal Church. Charlotte was a well-established southern city, whose black middle class had featured significantly in local history. North Carolina in general was home to a number of historically black colleges, normal schools, and proactive black churches. As noted by other writers on Alston's origins, the turn of the twentieth century in North Carolina, particularly in Charlotte, was a time in which blacks enjoyed a "window of opportunity" in terms of leadership and development of independent businesses and educational institutions. Because of such opportunities for personal and community gain, the black population in Charlotte doubled in ten years to make up one-third of the city's total by the 1870s.[1]

Reverend Primus Alston was a central figure in this dynamic period, and St. Michael's Church and its school played significant roles in the education of the city's black community. He was known as a "race man," a term then used to describe African American men who devoted their talents and resources to the furtherance of the race. A gifted orator, Reverend Alston often used the pulpit, as did many religious leaders of the period, to inspire his congregation. On the twenty-fifth anniversary of the Emancipation Proclamation, Alston delivered an address commemorating the occasion, stating, "In those dark days we were not regarded as human beings but as stock or cattle." In the same speech, he enumerated the contributions of every historically black college in existence at the time, calling on his congregation to support the schools.[2]

Reverend Primus Alston met his wife, Anna Elizabeth Miller, when she was a student at the school where he was principal. Several years her senior, Alston was a supportive husband, and Anna Alston was beloved

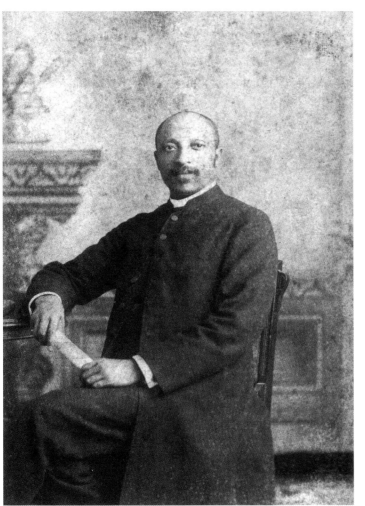

Figure 1. Reverend Primus Priss Alston. Photograph courtesy of Aida Bearden Winters.

by the women of St. Michael's congregation. The Alstons lived at 398 South Graham Street in Charlotte. Of their five children, only three—a daughter, Rousmaniere, and two sons, Wendell and Charles—survived infancy. As the family grew, they moved to a larger home at 416 West 3rd Street near Mint and Graham.[3]

It was Reverend Alston who dubbed Charles "Spinky," a nickname that would travel with him and endure through all his years as an artist among those who knew him best. Primus Alston left an indelible imprint upon his son. Although he died unexpectedly of a cerebral hemorrhage in 1910, when Charles was only three, his contributions to the local black community were so considerable that he was called the "Booker T. Washington of Charlotte." This larger-than-life figure would remain with Alston throughout his life, preserved in family stories and narrative vignettes from those who knew him. Reverend Alston's commitment to his people and to progress generated from within the community became basic to Charles Alston's own guiding principles.[4]

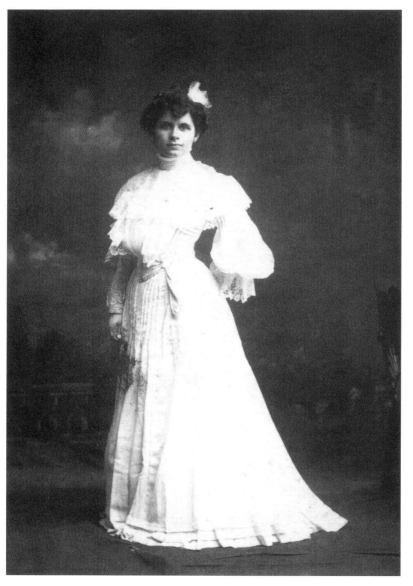

Figure 2. Anna Miller. Photograph courtesy of Aida Bearden Winters.

Interestingly, Alston's life parallels that of the painter Henry Ossawa Tanner, whose father, Benjamin Tucker Tanner, was also an activist, a "race man," and a bishop in the African Methodist Episcopal Church in Philadelphia. Like Bishop Tanner, Reverend Alston expressed an energy, drive, and determination that defined his life. Whereas Tanner took from his father his religious passion and used that background to create some of his most beautiful paintings, Reverend Alston's untimely death left Charles with only the cultural iconography of his father. To his family's credit, the name and legacy of Primus Priss Alston were kept alive within the family and remained a point of pride for the artist throughout his life.

Although Reverend Alston was revered in Charlotte and his death was honored with great ceremony, Anna Alston still had to experience the shock of suddenly becoming a widow early in life. In 1913, former classmate Harry Bearden proposed to her and she accepted. Through this marriage, Spinky and his siblings became cousins of their playmate Romare Bearden, nephew of Harry Bearden, and part of a large extended family for whom the arts were a central part of life.[5] Bearden, in fact, had been baptized on

November 19, 1911, at St. Michael's, and the two families lived across from each other on South Graham Street. In addition to becoming cousins, Bearden and Alston would remain lifelong friends: they worked together in New York, both drawing from their North Carolina roots for artistic inspiration. Years later, Bearden would recall playing ball with his older cousin Spinky on the front steps of the Charlotte branch of the United States Mint. Alston's sister Rousmaniere recalled how all the children of the Alston and Bearden clans would walk to the Southern Railroad station to see the trains come into town, especially the Number 37 New York-to-Atlanta special in the morning and the Number 38 in the evening on its way to Washington, DC, and points north.[6]

As long as he could remember, Alston was creating art. He credits his older brother Wendell with being a great artist whose drawings he would copy. Wendell designed locomotives and automobiles and had his room set up like an electrical engineering laboratory. Younger brother Spinky enjoyed imitating the inventive drawings of his older brother, who taught him at an early age to draw and design automobiles and other mechanical objects.[7] One of his earliest memories is creating sculpture out of North Carolina red clay as a little boy. Commenting on these early years, Alston recalled, "I remember North Carolina very vividly because even in those days (and I was very young) the red clay used to intrigue me. I'd get buckets of it and put it through strainers and make things out of it. I think that's the first art experience I remember, making things."[8]

THE MOVE TO NEW YORK

When Spinky Alston was about seven years old, the family moved to New York. Although Alston would be intrinsically connected to New York the rest of his life, his Carolina roots went with him. He would become recognized as one of a number of prominent African American artists—including Romare Bearden, Eugene Grigsby, and John Biggers—who came from North Carolina.

The Alstons' move reflected a mass surge northward of African Americans, called the Great Migration. The decline in cotton prices, flooding, and a boll weevil infestation created conditions in the rural South which—added to racial pressures—caused whole families to migrate to Harlem and to Negro areas of Philadelphia, Cleveland, Detroit,

Figure 3. "Spinky" Alston at two and one-half years old. Photograph courtesy of Aida Bearden Winters.

Chicago, Pittsburgh, and Saint Louis, where they found higher wages, less racial prejudice, and better educational opportunities for their children.[9]

The relocation disconnected Alston from his southern upbringing and thrust him, albeit as a child, into the midst of a tremendous socioeconomic wave that was irreversible in its force. Fortunately, by moving to New York around 1915, at the beginning of the Great Migration, the family fared better than those who arrived during the Depression. When the intense migration occurred in the thirties, the Alston clan was already settled. Having left Charlotte in advance of his family, Harry Bearden, Alston's stepfather, had secured a good job overseeing elevator operators and newsstand personnel at the Bretton Hotel on 86th Street and Broadway. The Beardens lived in several comfortable areas in Harlem before moving in 1926 to 1945 Seventh Avenue at 116th Street in "an elegant middle-class Jewish neighborhood," according to Gylbert Coker. Residing in buildings that opened their doors to select professionals "of color," the family benefited from the solid middle-class standing they brought with them from Charlotte.[10]

Nevertheless, the financial hardships that struck many families across the United States were even more intense for the residents of Harlem. Throughout the Depression, unemployment rates for Harlem blacks were at least one and a half times that of whites in the city.[11] As whites moved out and blacks moved in, the face of Harlem changed. Young Alston was a witness to and a participant in this transformation. The stoic strength his community demonstrated during this period would become a fundamental element of his work.

Southern African Americans brought not just their traditional folkways to the metropolis of New York but also their lingering memories of violence toward blacks throughout the South. In the summer of 1917, under the auspices of the NAACP, eight thousand African Americans marched silently down Fifth Avenue, bearing banners protesting lynching.[12] At the office of *Crisis* magazine, a flag flying outside the window indicated that a man had been lynched that day somewhere in the United States.

Despite the difficulties facing many African Americans upon their arrival in New York, Harlem was an incredible place for a young man to call home. The interplay between so many facets of cultural life in Harlem epitomized the social structure of middle-class black communities across the United States, where doctors, lawyers, clergymen, artists, musicians, and small-business owners intermingled. In the midst of the Depression, solidarity expressed through social exchanges was the glue that held the black community together. Families had their babies' pictures taken by James VanDerZee, and black men, regardless of their rank, had their hair cut at the same barbershop. African Americans went to the same churches, ate southern food at the same restaurants, and, although some services might be more elaborate than others, were buried by the same undertakers. From this interaction came a strengthening of resolve among Harlem African Americans to overcome injustice. Such palpable camaraderie would be the binding emotional connection evident in Charles Alston's painting *Walking* (Figure 4), which shows the force of movement of a unified people, striding purposefully across the horizon. Throughout his career, Alston would draw consciously and viscerally on the experiences of his Harlem youth, creating works of art that synthesized his knowledge and love of his people.

EDUCATION: REACHING HIGHER GROUND

Every child who grows up in New York City is shaped by the place, and Charles Alston was no exception. Education was a family priority, and a college degree was rightly regarded by his elders as the kind of security that he would need as an African American male. It was not serendipitous that Alston studied at Columbia University at a time when most African American males could not afford to consider a college degree, much less attend an Ivy League institution. The Alston clan fit solidly within the spectrum that W. E. B. DuBois had characterized as the "Talented Tenth," the group that would take on the mantle of responsibility and leadership required to move the race ahead. With education and religious leadership as part of his family legacy, Alston knew at an early age that he was destined to be part of this elite group. He attended DeWitt Clinton High School, a public school known for its excellence in academic achievement. Then an all-boys institution, with the atmosphere of a highly competitive private school, DeWitt Clinton boasts such distinguished

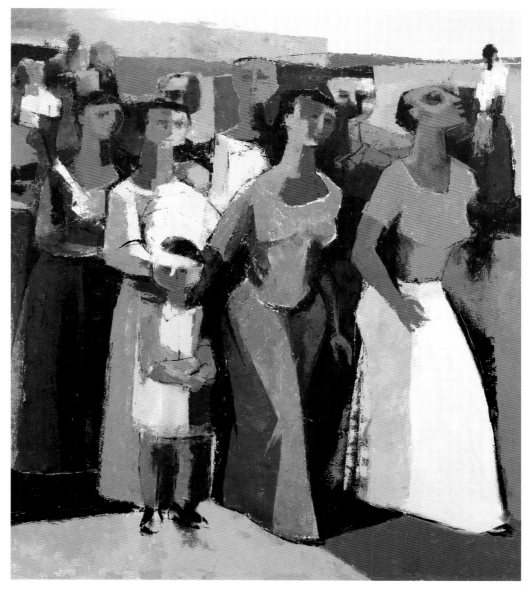

Figure 4.
Walking (detail of Plate 39), 1958.
National Museum of African American History and Culture, Smithsonian Institution.

alumni as Walter Hoving, Richard Avedon, James Baldwin, Paddy Chayefsky, Romare Bearden, Avery Fisher, Countee Cullen, and Burt Lancaster.

According to Gylbert Coker, Alston was elected to Arista, an honorary society at DeWitt Clinton for students of excellent achievement, and he was also selected to be art editor of the school's annual magazine, *The Magpie*. On Saturdays, Alston took classes at the National Academy of Art. As a senior, he received a perfect score on the extremely competitive New York Regents examination in physics.

Alston's varied accomplishments were due, in part, to the rich cultural traditions that surrounded him. His love of art was fostered by his family, and he received his first oil paints while in high school. During this period, Alston would have been aware of the art salons hosted by his aunt Bessye Bearden. A community leader and New York editor of the *Chicago Defender,* she held regular gatherings at her home that were attended by such black cultural stars as Langston Hughes and Duke Ellington.[13] Alston and Ellington would later become close friends, and Alston created nearly one hundred drawings and caricatures of the famous musician at the piano. Alston's stepfather, Harry Bearden, was a great lover of opera, so all types of music filled the household.

After graduating from DeWitt Clinton High School in 1925, Alston entered Columbia University. He was incredibly pragmatic about his decision to attend Columbia and apparently well prepared for the climate there. He had been awarded a scholarship to the Yale School of the Fine Arts in 1925, but he turned it down because, in his view, he needed a more broadly based education in order to make a living. As the artist stated, "I thought perhaps going into a school of fine arts might limit the other cultural aspects that I was interested in. I was interested in music and poetry and the theatre. And I wanted as broad an education as I could get. I've never regretted that decision, as a matter of fact."[14]

During his first two years at Columbia, Alston explored various courses of study. He initially felt that he should pursue a field in which he could use his artistic skills and still benefit from a greater "promise of security." He considered architecture, but upon learning how much math was required in the program, he began to have doubts. At the same time, he was carefully observing African American architects in his community and saw that their careers were stifled by limited opportunities to bid for the truly creative projects. Noted Alston, "I stayed in pre-architectural work for about a year and when I saw what was happening particularly to Negro architects, I mean redesigning storefront churches and that kind of thing, that didn't appeal to me at all." The following fall, after having spent the summer working with a group of premedical students at a hotel in Glen Cove, Long Island, Alston was briefly encouraged by their youthful enthusiasm to enter the field of medicine. Once again, reality set in and Alston, after enrolling in physics and chemistry classes, quickly determined that this was not a field that suited him either. Alston reflected with good humor, "When I got through with physics and chemistry and all that foolishness, I realized that was just not my bag. So finally I did what I should have done all along; just took a general course majoring in fine arts and history."[15]

It is certainly to the credit of Alston's family, paticularly his mother, that he was supported during this period of self-determination. Like so many students at liberal arts colleges, Alston used this time to explore what truly mattered to him in his life goals and course of learning. For many African American families, art is a field that is not encouraged because it is not seen as economically secure. For most, a Columbia education would have been regarded as an opportunity to move directly into a professional field that guaranteed wealth and security. But Alston's mother and other elders, appreciating that his love of art had been evident throughout his young life, wisely supported him through his academic explorations to his ultimate decision to study fine arts.

Even after Alston chose his field of study, time at Columbia was defined by challenges. Since he was one of only a handful of black students enrolled there, it was an isolating experience, one in which he had to constantly "wear that air about you that will demand respect," as his father had exhorted his congregation in his famous Emancipation Proclamation sermon.[16] So, like other African Americans who attended largely white institutions of higher learning, Alston created outlets for himself. He joined the Alpha Phi Alpha fraternity, thus giving himself a social base. He worked on Columbia's *Spectator,* and drew cartoons for the school's monthly magazine, *The Jester,* just as he had worked on publications in high school. Having grown up in Harlem, Alston knew the neighborhood, so his social sphere was largely off campus. He frequented familiar haunts such as Pod's and Jerry's on 133rd and Lenox, or Annie Young's, where he could always get a good meal.[17] His love of jazz and black music in general developed during this period and would become a major force in his art throughout his life.

Figure 5. Alston on graduation day at Columbia University with his mother and grandmother. Photograph courtesy of Aida Bearden Winters.

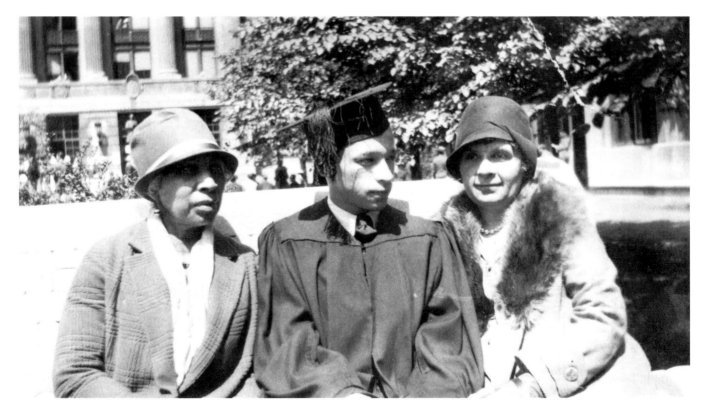

In his frank and insightful 1968 interview with musician and historian Albert Murray, Alston discussed the atmosphere at Columbia, which he felt had remained unchanged through the years: after four decades the experience was still difficult for African American students. As he put it, there were "subtle things that indicated Columbia's attitude." For instance, as a student he was exempted from life drawing classes because a white model might be used. Although figure drawing was a prerequisite for other art courses, Columbia administrators decided that Alston should skip that step. Such incidents led the artist to conclude that the school did not play straight on matters of race in his day: he sympathized with late-1960s Columbia undergraduates who were demanding more black students and faculty members, as well as an African American studies program: "Whether I approve of all their tactics or not, I think they at least have the guts to articulate and do something about things that have griped any number of generations of Negroes who've come through Columbia."[18]

Although he was disappointed by the school's policies, Alston still recognized the importance of an education at Columbia and the access that the university afforded its students to professional training. He graduated in 1929, and with the support of one his college instructors, Sally Tannahill, he received an Arthur Wesley Dow Fellowship for study at the Teachers College of Columbia University.[19] There Alston received his first introduction to modern art. Many of the teachers had lived and worked in Paris and brought an awareness of the international art scene to their teaching. Instructor Charles Martin was particularly influential in Alston's development as an artist. A highly regarded watercolorist, Martin gave Alston the opportunity to assist him in his class. Alston observed: "He was a tough man. He didn't soft-soap you about anything. If it was bad, it was bad. He didn't care how hard you had worked on it."[20] In 1931, Alston received his master's degree from Teachers College.

Much of the cultural education that Alston received immediately after graduating from Columbia was not in the classroom but rather in the great laboratory of creativity known as Harlem, USA. Alston relished all that it had to offer:

> Harlem was a fantastically interesting place in those days, in 1928, 1929. Harlem was
> really a cultural center in this town. . . . The thoroughfare, the promenade was
> Seventh Avenue. And Seventh Avenue was a very handsome street, and on a Sunday
> you'd stroll along Seventh Avenue in your best clothes and look over the passing
> parade of beautiful gals, you know. The 135th Street corner was our meeting place.
> You could stand there and in the span of a Sunday afternoon see anyone who was
> anybody in Harlem.[21]

Equally important was the opportunity for intellectual exchange so readily available throughout Harlem. Alston spent time with great writers such as Langston Hughes, Claude McKay, and Wallace Thurman. But while the richness of Harlem life provided an unforgettable education for Alston, he simultaneously recognized that many of the young artists being promoted had limited talents. "It got to be a vogue," he said. After that vogue went out of fashion, they were left lost and confused.[22]

Perhaps Alston's greatest pleasure was spending time with the musicians and singers who performed in Harlem's clubs. There performances were judged by seasoned audiences who could be merciless if the music was not up to their standards. (These audiences were the predecessors of the notoriously tough Apollo Theater crowds of the 1950s.) The late-night Harlem club sessions would serve as a major source of inspiration for Alston later, when he painted several series devoted to jazz and the blues:

> The night life was fabulous. The corner saloons, back rooms jumped. . . . You'd go into Hotcha, and Bobby Henderson was playing the piano, Billie Holiday was singing. You'd go across Lenox Avenue to the little bar across from Harlem Hospital, and Art Tatum was playing the piano. Ethel Waters was [there]. The place just jumped. Dickie Wells' place on 133rd Street—God, some of the names escape me. Tillie's Chicken Shack. Gladys Bentley's place. And you sort of did a tour. In the evening you'd pop from place to place. . . . You had as many people from downtown in Harlem in those days as you had Negroes, and nobody thought of anything happening to them. . . . Some of these little joints you had to go down through a basement . . . through a yard and have people open up so you could be identified, but it never occurred to you that anything would happen. That's a long time ago.[23]

None of Harlem's residents, especially the artists, wanted to miss any of the amazing talent that one could witness on any given evening. During this period, Harlem also became a destination for wealthy whites, and "slumming" at the Cotton Club became fashionable. Harlem residents sidestepped these well-heeled, curious visitors to their neighborhood; they had their own haunts. Alston, Romare Bearden, and Eddie Morrow formed the nucleus of the "Dawn Patrol," a group that took its name from a column written for the *Amsterdam News* by Ted Yates. Together with friends like Peter Arno and *New York Post* critic Archer Winston, they would hit the after-hours spots. Observed Romare Bearden:

> The thing in Harlem in those days was that the bars closed at 3 A.M., and then everybody went to after-hours places. . . . Here were we, the young artists, looking on at all of this. I'd say that we young artists had the same kind of ambiance that Toulouse-Lautrec had. It was a very interesting time. You'd want to be either in Harlem then or in Paris.[24]

REACHING THE YOUTH

While pursuing his master's degree, Alston served as boys' work director at the Utopia Children's House (also called Utopia Children's Center), a big brownstone at 170 West 130th Street that provided day care, hot lunches, and an after-school arts-and-crafts program. The program was created by James Lesesne Wells, who went on to teach at Howard University. Alston retained the

structure that Wells had established, offering children's classes for various age levels and adult classes in the evenings. Around the same time, he began to teach at the Harlem Art Workshop, which Augusta Savage had established in the basement of the 135th Street branch of the New York Public Library—now the Schomburg Center for Research in Black Culture. When the Carnegie Foundation ceased funding the workshop, Alston reopened it with the assistance of the Works Progress Administration at 306 West 141st Street, in the studios he shared with Henry Bannarn and other artists. Known simply as 306, the place became a center for the most creative minds in Harlem.[25]

The ease with which Alston navigated between the worlds of Columbia University and Harlem, so vastly different yet geographically almost next-door neighbors, parallels the ease with which he moved through the many spheres—racial, cultural, educational, social, and political—that defined his daily life during these busy years. In addition to the demands of graduate school, Alston, still in his twenties, took on the organizational responsibilities of several community programs. His sense of how to live a purposeful life as an artist, in a time filled with exciting distractions, major economic challenges, and myriad philosophical views, demonstrates an exceptional maturity at such a young age.

Alston taught many children during this period, including the young Robert Blackburn, who later became a master printer. Clearly his most important student was Jacob Lawrence. At the age of twelve or thirteen, Lawrence began coming to Utopia House, where Alston coordinated after-school activities. Alston recalled, "I had an art class as one of the activities, and Jake was interested. And I noticed almost immediately what an interesting eye this kid had. He didn't work like the other kids. He knew pretty definitely what he wanted to do, and it didn't relate to the typical kind of thing that children of that age do. At that time he was interested in very fantastic masks."[26] Alston's precocious student also painted nonfigurative geometric designs and created three-dimensional stagelike tableaux in small boxes. In subsequent years, Lawrence continued to study with Alston at the WPA Harlem Art Workshop.[27]

In her essay "The Education of Jacob Lawrence," Elizabeth Hutton Turner noted that Alston followed the teachings of John Dewey, who had taught at Columbia for many years.[28] Fresh from his Teachers College experience, Alston applied Dewey's philosophy to his own classroom structure. Dewey advocated that the student should lead the way into an experience and that the teacher's lesson should follow. According to Dewey, "Learning comes from seeing and doing, doing and undoing." Consequently, Alston did not teach Lawrence to draw, but when he found Lawrence drawing masks, he showed him how to make life-size ones out of papier-mâché. From Professor Thomas Munro at Columbia, Alston would have learned the idea that "art is not description; art comes from inside, from perception, from emotion, from imagination," the basis for Munro's idea of a "selective and reconstructing eye."[29]

Turner further noted that Alston also most likely adopted for the classroom the practices of Arthur Wesley Dow. A pioneer in the field of art education, Dow had been chair of the Department of Fine Arts at Teachers College, and his book *Composition* was one of the first texts to make art practices accessible to the general public.[30] One of the critical aspects of Dow's teach-

ing philosophy was his blurring of the boundaries between fine art and decorative art. This made the creative process much more democratic. Adopting this view, and utilizing his own sensitivity as a teacher, Alston was able to reach the young Lawrence in a way that was comfortable and encouraging. By asking him to use geometric patterns to design a rug, Alston placed Lawrence back in his own environment, since his mother had made "colored rugs and patterns and that type of thing."[31] Alston enabled the young student to learn about pattern and geometry through his own personal visual experiences.

As he drew upon his studies from graduate school, Alston learned to apply his own personal approach to teaching. The structure of James Lesesne Wells' workshop worked well for him in reaching young and old artists from the community, and he chose not to alter that core approach.[32] Throughout his years as an instructor he was encouraging and approachable—his students recognized him as an exceptional educator.

Jacob Lawrence quit Commerce High School when he was seventeen, but he continued to study with Alston and Bannarn at the WPA Harlem Art Workshop, renting space in the corner of Alston's studio until 1940. He exhibited his work in group shows at 306 and in a 1936 solo show hosted by cabinetmaker Addison Bates. Alston wrote the introduction to Lawrence's first public one-man exhibition: held at the 135th Street Library in 1938, it was sponsored by the James Weldon Johnson Literary Guild. Lawrence was not yet twenty-one, but Alston saw much in him, commenting in an exhibition publication, "Still a very young painter, Lawrence symbolizes more than any one I know the vitality, the seriousness and promise of a new and socially conscious generation of Negro artists."[33] That Alston's observations still ring true today attests as much to his acuity as a teacher as to Lawrence's talent as an artist. As Turner stated, "Even though Alston said that he did not teach Lawrence, a bond developed between the younger artist and his teacher. Alston, in fact, considered Lawrence like 'a son.'"[34] As his mentor, Alston introduced Lawrence to Alain Locke, a major architect of the Harlem Renaissance. That meeting in turn led to Lawrence being asked by art dealer Edith Halpert to join her Downtown Gallery. Alston recalled that Walter White, a leader of the NAACP in New York and a major intellectual force in Harlem, had been a similar mentor to him, including him at meetings and parties with older, influential African Americans and Europeans—such as Carl Van Vechten—who could help and encourage such a promising young man.[35] Alston provided a similar experience for Lawrence.

The nurturing, encouragement, and respect that the older black man showed the younger led Lawrence to comment years later that the depression he suffered from in his early thirties was due in large part to the great burden of guilt he felt for having made it into the most rarefied of art circles—while leaving behind his generous, talented, and inspiring elders.[36] Alston also encouraged his cousin Romare Bearden to continue his studies in night classes with George Grosz at the Art Students League, and Bearden credits Alston with teaching him much about painting.

The relationship between Lawrence and Alston bears consideration, for it reveals the true nature of Alston as a human being and an artist. The longevity of this student-teacher relationship—over ten years—ran counter to what many consider a restlessness in Alston's character as an artist. Consistency and dedication were qualities that Alston embodied as an educator, in this instance, for

the sake of turning a precocious child into a cutting-edge artist. How many would have taken the time to carefully plan activities to cultivate the talents of a twelve-year-old? Alston took an extremely proactive stance with Lawrence. Having to adjust his role as mentor to that of equal when his protégé began to gain recognition, Alston welcomed Lawrence and his young bride, Gwendolyn Knight, into his circle of friends at 306 and then witnessed his incomparable rise, like a star above Manhattan. The flexibility and sensitivity with which he faced such human situations was also characteristic of his very personal approach to his art. Thus instead of viewing his movement from painting to drawing, and then to sculpture, commercial illustration, and mural painting as restlessness, we should regard it, as did Alston himself, as the expression of artistic freedom.

CHAPTER ONE ENDNOTES

1. Myron Schwartzman, *Romare Bearden: His Life and Art* (New York: Abrams, 1990), p. 14.

2. Lemoine D. Pierce, "Charles Alston—An Appreciation," *The International Review of African American Art* 19, no. 4 (2004), p. 36.

3. Schwartzman, *Romare Bearden*, p. 14.

4. "Primus Alston was born into slavery in 1851 in the town of Pittsboro in Chatham County on Rocky River, near Siler City, N. C. Some time after the Civil War, he made his way to Raleigh and enrolled at St. Augustine's College, founded in 1866 by Episcopal clergy to educate freed slaves for the ministry. At age 41, he was ordained an Episcopal priest, and soon after, believing that education of the freedman in the community was a priority, he took charge of the Colored Mission of St. Michael's and All Angels of St. Peter's Episcopal Church in Charlotte." Pierce, "Charles Alston," p. 33.

5. Schwartzman, *Romare Bearden*, p. 15.

6. Ibid., pp. 20–21.

7. Charles Alston, "Oral History Interview with Charles Alston," interview by Al Murray, October 19, 1968, transcript, Smithsonian Archives of American Art, p. 12.

8. Ibid., p. 1.

9. Howard Dodson and Sylviane A. Diouf, *In Motion: The African-American Migration Experience* (Washington, DC: National Geographic Society, 2004), p. 119.

10. Gylbert Garvin Coker, in the "Biographical Chronology" she contributed to the exhibition catalog *Charles Alston: Artist and Teacher* (New York: Kenkeleba Gallery, 1990), carefully documented the moves that the Beardens made once in Harlem. She noted that they lived in "several comfortable brown-

stones" and that "later, the family moved again to a larger apartment on 98th Street. Three buildings on 98th Street had Black residents: No. 55, No. 57, and No. 59. The rest of the block was Irish, German and Italian." Regarding their residence at Seventh Avenue and 116th Street, Coker wrote, "Buildings like No. 1945 . . . were elite homes that had recently opened their doors to people of 'color.' These particular building were cooperatives, admitting only those who were well established professionals from 'good' families."

11. Morgan Smith and Marvin Smith, *Harlem: The Vision of Morgan and Marvin Smith*, edited by James A. Miller (Lexington: University Press of Kentucky, 1998), pp. 6–7.

12. Howard Dodson, Christopher Moore, and Roberta Yancy, *The Black New Yorkers: The Schomburg Illustrated Chronology* (New York: John Wiley & Sons, 2000), p. 156.

13. National Gallery of Art, "The Art of Romare Bearden: A Resource for Teachers," http://www.nga.gov/education/classroom/bearden/bio1.shtm.

14. Alston, "Oral History Interview (1968)," p. 2.

15. Ibid.

16. Pierce, "Charles Alston," p. 36.

17. Coker, "Biographical Chronology," p. 20.

18. Alston, "Oral History Interview (1968)," p. 3.

19. Alston's instructor in commercial art, Tannahill excelled in calligraphy, and one of her books included examples of Alston's calligraphic designs. Romare Bearden and Harry Henderson, *A History of African-American Artists: From 1792 to the Present* (New York: Pantheon, 1993), p. 261.

20. Ibid.

21. Alston, "Oral History Interview (1968)," pp. 3–4.

22. Ibid., p. 4.

23. Ibid.

24. Schwartzman, *Romare Bearden*, pp. 88, 92.

25. Coker, "Biographical Chronology," p. 21.

26. Alston, "Oral History Interview (1968)."

27. Peter Nesbett and Michelle DuBois, editors, *Over the Line: The Art and Life of Jacob Lawrence* (Seattle: University of Washington Press, 2000), pp. 25–26.

28. Elizabeth Hutton Turner, "The Education of Jacob Lawrence," in *Over the Line*, p. 98.

29. Ibid., p. 99.

30. Ibid., p. 98.

31. Ibid., p. 99.

32. Charles Alston, "Oral History Interview with Charles Alston," interview by Harlan Phillips, September, 28, 1965, Smithsonian Archives of American Art, p. 3.

33. Milton W. Brown, *Jacob Lawrence*, exh. cat. (New York: Whitney Museum of American Art, 1974), p. 9.

34. Turner, "Education of Jacob Lawrence," p. 97.

35. Alston, "Oral History Interview (1968)," p. 3.

36. Interview with Jacob Lawrence and Gwendolyn Knight Lawrence, Seattle, Washington, 1987.

LIVING THE RENAISSANCE

"306"

O f there was a single space that defined the energy and creativity of the Harlem Renaissance, it would have been 306 West 141st Street. Unlike A'Lelia Walker's salons, which were carefully orchestrated events punctuated by performances, 306 represented a free-flowing forum for artistic exchange, work, conversation, and social interaction. With sculptor Henry Bannarn, Alston hosted a range of uptown and downtown artists, writers, musicians, collectors, and social activists. A typical gathering at 306 might see anyone come through the door from Aaron Douglas to Duke Ellington to William Saroyan. The famous photograph taken of 306 regulars by African American photographers Morgan and Marvin Smith in the mid-1930s shows Alston standing in the center, surrounded by young African American artists dressed in their winter finery. The image speaks to the pride, style, and sense of connection that black artists felt during the period, while it indicates a keen awareness of the historic significance of the meeting of so many Harlem intellectuals.[1] Romare Bearden offered the following summary of how his cousin developed this art space:

> At 306 West 141st St., he found an old stable whose hayloft could be converted into a large studio classroom. The building also contained two apartments, one of which he took. The other went to Henry W. "Mike" Bannarn, an African American sculptor and fellow teacher then living in cramped YMCA quarters. Known as "306", the building became one of the leading intellectual and artistic centers of Harlem.
>
> Harlem then resembled a small town. Almost all creative people in the arts knew one another, as well as the leading ministers, physicians, lawyers, business leaders, and national political figures like James Weldon Johnson and W. E. B. DuBois. Alston began inviting people he knew from the WPA to social parties. These turned into intellectual discussions and 306 rapidly became a unique community institution. It particularly attracted artists, writers, musicians, actors, dancers, and designers, who were excited to discover one another's talents and views. Even Philadelphia, Washington, and Chicago artists showed up—and sometimes Alain Locke. On payday, the partying and discussions at times spilled over into the huge studio classroom. What black artists achieved in one field stimulated all the others, created deeply satisfying waves of appreciation that went beyond mere applause.[2]

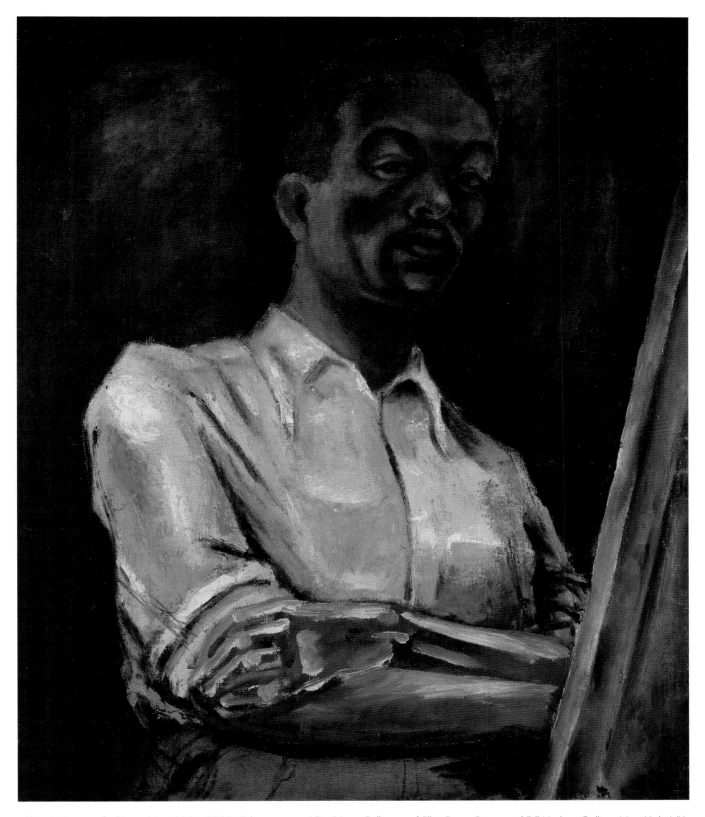

Plate 1. *Portrait of a Young Man*, 1936–1938. Oil on canvas, 19 x 16 in. Collection of Elliot Perry. Courtesy of Bill Hodges Gallery, New York, NY.

In addition to Henry Bannarn, who stayed at 306 and had studio space there, Addison Bates and his brother Len, both furniture makers and artist's models, also rented apartments over the studio area at 306. Downstairs in the workshop area, there was always a class or some activity taking place. Bannarn and Alston studied sculpture with Ahron Ben-Shmuel, who regularly taught sculpture to children at 306.[3]

To Jacob Lawrence, who also had a small studio space at 306, the place was very much a community:

> I would hear the talk about the various problems in their special fields of acting, the-
> ater, and so on. It was stimulating and very rewarding—I didn't realize *how* stimulat-
> ing it was at the time, because I was too young to fully appreciate it. Romare
> Bearden was one of the younger people who frequented "306," and he told of his
> experiences. He was an intellectually curious person in regard to his painting. He was
> experimental and scholarly, very much involved and curious, and studied the old
> masters and the moderns. He attended the exhibitions outside of the Harlem com-
> munity—galleries and museums. And he would come back and talk about these
> things, as everyone did about their own experiences.[4]

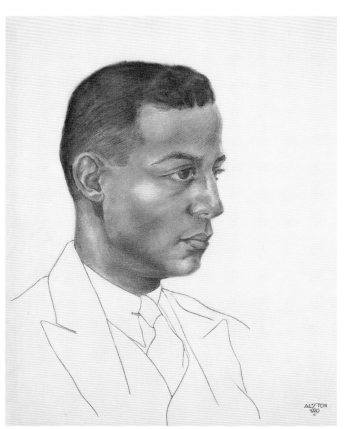

Much of the conversation that occurred at 306 was not simply comparative aesthetics but also political strategizing in the New York art world. Artists examined and discussed ways in which to break into the gallery scene, to gain major commissions, to work for the WPA. At the first meeting of the American Artists Congress at New York City's Town Hall in 1936, Aaron Douglas took major art institutions to task for their exclusion of serious Negro art. He also named three artists who had made a significant impact on the country—William H. Johnson, Hale Woodruff, and Archibald Motley—and went on to say of the new generation, "Among our young artists of sound talent and definite promise are Wells, Porter, Alston, Bannarn, Hardwick, and Bearden."[5]

Many of the artists who were 306 regulars were also members of the newly organized Harlem Artists' Guild. Established by sculptor Augusta Savage with Charles Alston and Elba Lightfoot, the guild was vocal in its concern about the lack of African American participants in the WPA art programs in New York City.[6] Through the organized efforts of the guild, artists were able to participate in a larger num-ber of projects, including the Harlem Hospital murals. Savage, who taught both Jacob Lawrence and Gwendolyn

Knight, worked especially hard to see that the two young artists gained experience through WPA opportunities.

During the rich and complex time of the thirties, Alston worked seriously on his own art while helping to organize the Harlem Artists' Guild and holding lengthy dialogues with his fellow artists at 306. He was able to balance this camaraderie with his need for isolation at the canvas. Indeed, one seemed to inspire the other. Alston's works from this period reveal his emphasis on portraiture and genre scenes. *Portrait of a Man* (Figure 6), a pastel created in 1929, is largely realistic and shows Alston's mastery of his medium and of the human portrait. The subject is a handsome figure with an intelligent gaze. His stylish haircut is accurately rendered, showing a fullness at the top and gradual fading on the sides. The rich tones of his skin are carefully presented with highlights along his cheekbone, brow, and chin. The steady gaze of the man suggests a serious persona.

What is striking about *Portrait of a Man* is Alston's adoption of the technique and style of Winold Reiss, known for his beautifully crafted portraits of Harlem Renaissance figures such as Langston Hughes and Alain Locke, rendered in pastel against a blank background, as in this work. The restraint with which Reiss created these images, with full coloration of the head and a simple delineation of the torso, was his signature technique in portraiture. Alston's work similarly places greater focus upon the face while providing only a spare outline below, much like a contour drawing. This work demonstrates not only Alston's facility at realistic drawing but also his early eagerness to master any technique that interested him and to explore many artistic styles. For Alston, the creation of *Portrait of a Man* may have been a practice exercise, just as an artist would copy a painting by an old master. The work is even signed in the same blocky print style used by Reiss.

In contrast to *Portrait of a Man* is the oil painting *Portrait of a Young Man*, dated 1936–1938 (Plate 1), a very thoughtful, more commanding work. Here, a man, standing in front of an easel, gazes out from a dark surround. Dressed in blue shirt and trousers, Alston looks out with great self-assurance, as if he knows the viewer well. His expression is one of serious confidence; his eyes beneath raised brows are those of a sophisticated New Yorker who, at approximately twenty-nine years of age, has a burgeoning career ahead of him and the creative energy of the Harlem Renaissance around him. His face, complete with moustache, has that same slightly smiling, knowing gaze that he had in the famous photograph of his 306 group, which brought together some of the greatest talents and intellects of the era. Arms folded (but without the paintbrush that would have immediately identified him), he is at once guarded and assertive, his body language an expression of power. This is the urbane Alston at his best. In

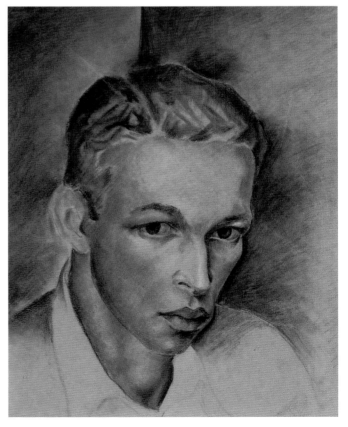

Figure 7. *Self-Portrait*, 1930s. Pastel and charcoal on paper, 13 1/2 x 10 3/8 in. Courtesy of Bill Hodges Gallery, New York, NY.

presenting his image out of darkness, with highlights on his face, he establishes a classic setting for himself, creating a self-portrait for the ages.

Another self-portrait of the 1930s (Figure 7), done in pastel shades of gray, shows a more sensitive and contemplative image of the artist.

Careful study of these two self-portraits suggests that the 1929 pastel is also a self-portrait. The similarities lie in the mouth, the hairline, the brows, and the contemplative pose. Similarly, the untitled portrait bust of a man (Figure 8) also appears to have the features of a young Alston and the thoughtful expression. Alston's interest in expressing self-examination in his portraits is significant and reveals an important element of his character. He recalled that his first oil painting, completed when he was a teenager, was a self-portrait.[7]

From his endeavors to master all of the techniques of portraiture, Alston created images that would become classics of the period, such as *Girl in a Red Dress* (Plate 2) and *The Blue Shirt* (Plate 3). Both have come to be regarded as magnificent studies of African American youth. *Girl in a Red Dress* has become a symbol of the Harlem Renaissance, much like Archibald Motley's jazz scenes. Featured in Richard Powell's exhibition "Rhapsodies in Black: Art of the Harlem Renaissance," Alston's depiction of the engaging intellect of the young woman and her serious self-confidence convey to the world a different kind of beauty. The work reflects the intellectual and creative energy that surrounded Alston at the time, generated by Richmond Barthe, Aaron Douglas, and Alain Locke, for instance. The girl has an expression of thoughtful maturity, accentuated by her white collar, her attention to visual detail noted in her choice of simple, globular, matching red earrings.

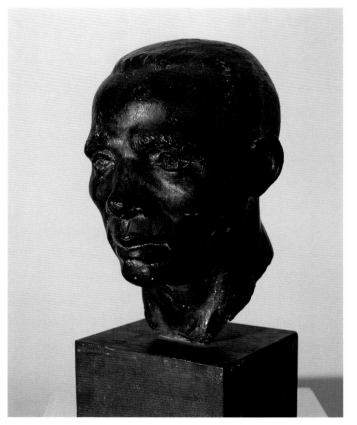

Figure 8. *Untitled (Head of a Man)*, 1937. Plaster, 11 ³/₄ x 7 x 8 in. Courtesy of Bill Hodges Gallery, New York, NY.

Alston's composition is removed from the tradition of creating a specific background that places the figure in a certain time and locale. Instead, Alston makes the image universal and depicts the subject from her inner vantage point. This image is the first of many that focus on the color red.

Nowhere is Alston's personal and engaging approach to painting more expressive than in *The Blue Shirt,* an equally thoughtful painting of African American youth. Here, the boy looks out with a question in his eyes, facing an unknown future, pondering the weight of what he sees. Powerful in its simplicity, the work focuses on the solemn expression of the boy who, seated for the portrait, is probably uncomfortable with the formal setting and having to sit for a long time, wondering what the artist sees, wondering what he must look like on canvas.

In painting such a portrait, Alston has taken the opportunity to examine his own people, just as artists from other periods have made the unknown man, woman, or child famous for the ages. In a period leading

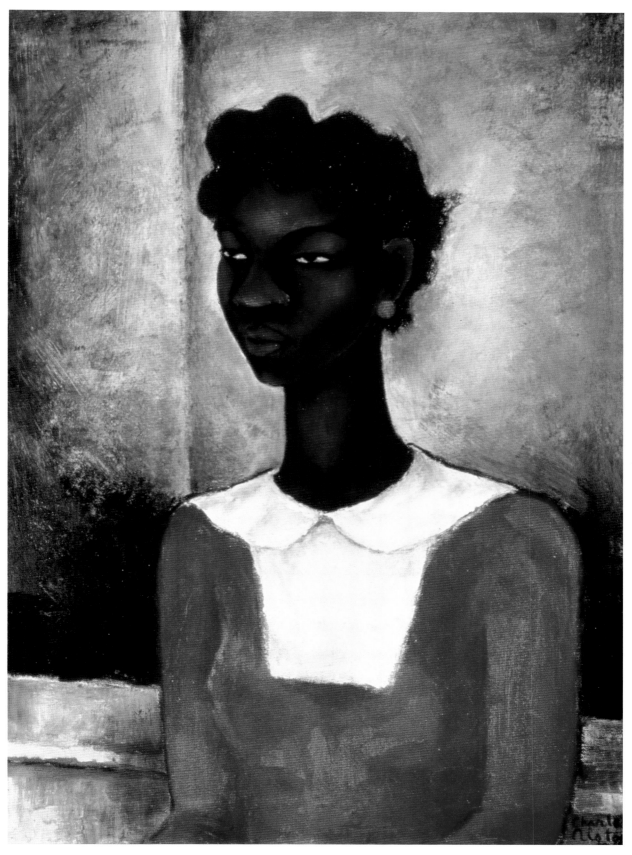

Plate 2. *Girl in a Red Dress*, 1934. Oil on canvas, 26 x 22 in. The Harmon and Harriet Kelley Foundation for the Arts.

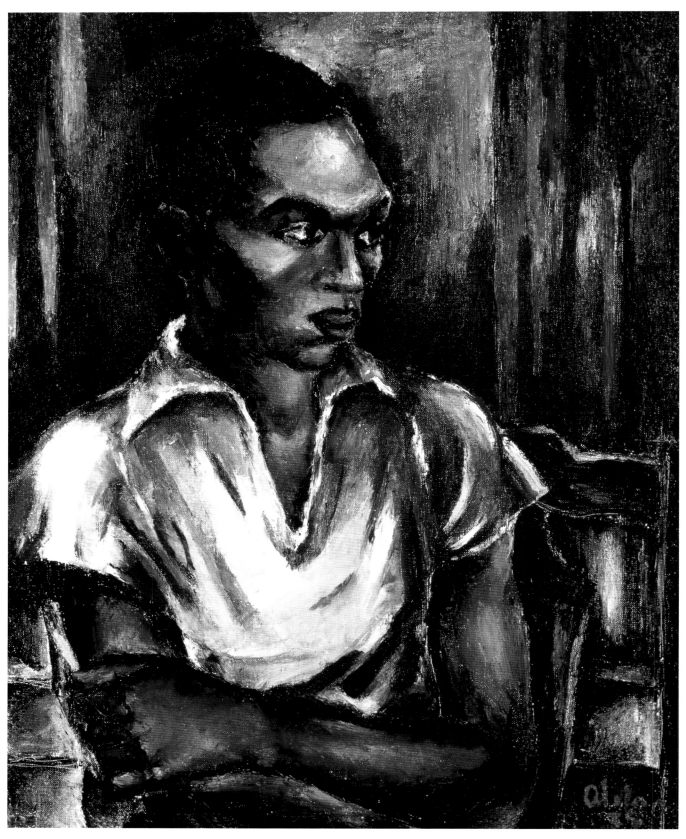

Plate 3. *The Blue Shirt*, 1935. Oil on canvas. The Harmon and Harriet Kelley Foundation for the Arts.

up to a war fueled by racist propaganda, in a time when DuBois wrote daily about lynchings occurring in the South, these depictions of black youths are expressions of racial affirmation. In the face of widespread stereotypical imagery, Alston drew on genre scenes and familiar faces to present these serious works. Just as Langston Hughes and Claude McKay, both of whom were friends of Alston, wrote about dignity and defiance, Alston captured these qualities in his early paintings.

What makes *The Blue Shirt* even more extraordinary is the possibility that it is a portrait of a young Jacob Lawrence. First suggested by curator Elizabeth Hutton Turner of the Phillips Collection, the idea gained credibility when Lawrence during his later years, visited collectors Harmon and Harriet Kelley in San Antonio and confirmed that the work could very well be a portrait of himself by Alston.[8] If the subject is indeed Lawrence, the picture provides further evidence that Alston saw the exceptional nature of this young boy and chose to express that nature to the world. The image certainly bears the same sense of quiet contemplation that marked Lawrence's personality, as seen also in early photographs.

Just as Alston captured the essence of black youths, so too did he seek to capture the mystery and dignity of the figure in *Man Seated with Travel Bag* (Plate 4). The racial identity of the man is blurred, which may have been deliberate. The work is a classic genre image set in New York City in the mid-thirties, the epicenter of the American melting pot. Seated, wrapped in his coat, with his hat pulled down on his head, the figure bespeaks migration, having traveled either across the Atlantic, with a pause at Ellis Island, or up the Mississippi, to make Harlem a new home. Holding his valise on his lap, with weariness and sadness in his eyes, he is a man moving, trying to keep up with life and make a way for himself. The intersection of trajectories where diverse cultures met would always intrigue Alston.

The painting offers a classic slice of New York life, the brief glimpse of an enigmatic figure one might encounter on a bus or train. The man was probably someone that Alston saw as he moved about the city during the course of his day, someone whose plight struck the artist. This is the same kind of attention to the poetic grit of everyday existence that Jacob Lawrence would focus upon in his *Migration* series (1940–1941). The dark palette of *Man Seated with Travel Bag,* with broad rectangular passages of blue, underscores the dreariness of the man's countenance. He is Manhattan under duress: edgy, sinewy, and solemn.

On a seemingly different note is the color-filled 1930 work *Vaudeville* (Plate 5). Painted in watercolor against a stark white background, the figure initially looks like a simple caricature, a stylized image of black entertainment such as the Mexican artist Miguel Covarrubias did of black dancers. However, closer examination shows that Alston has deliberately cast a different light upon the figure. The black man in blackface stands with his gloved hand extended to take a bow. He wears a red-toned checkered suit, green vest, and floppy red bow tie. His huge frame is supported only by mustard-colored clown shoes. A bowler hat perches jauntily on the man's head. It is his face that draws us in. With eyes wide open, he looks down at the audience almost in fright as he takes his bow. A reddish aura surrounds his figure; this is his shadow as cast from a spotlight shining down upon him. To his left, a wavy line moves across the stage as

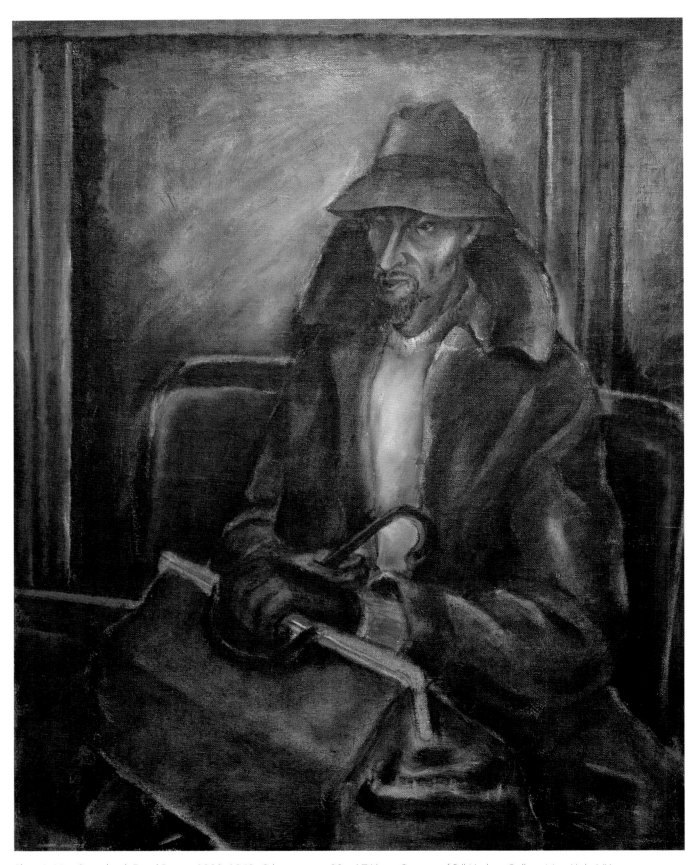

Plate 4. *Man Seated with Travel Bag*, c. 1938–1940. Oil on canvas, 22 x 17 ½ in. Courtesy of Bill Hodges Gallery, New York, NY.

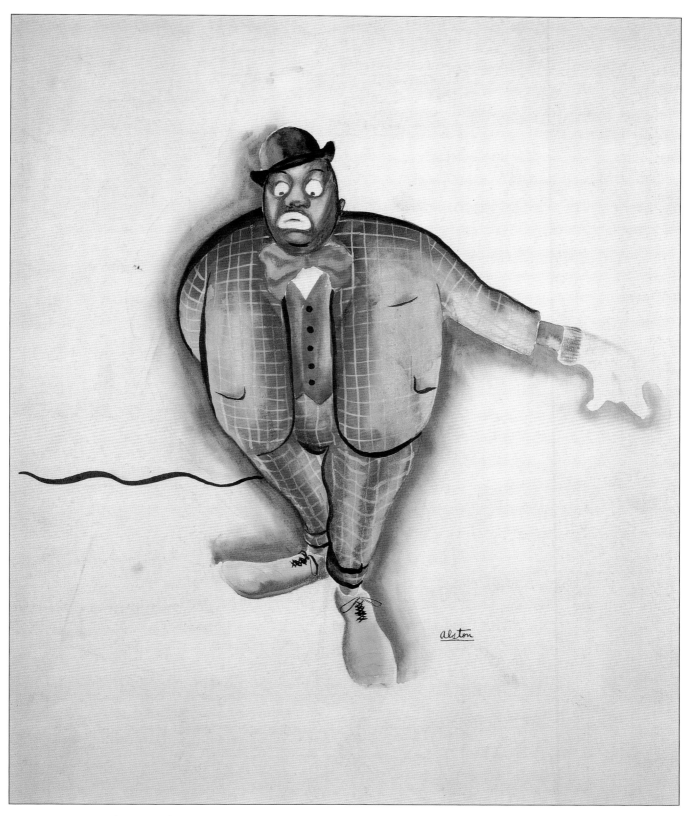

Plate 5. *Vaudeville*, c. 1930. Watercolor on paper, 20 x 14 ½ in. Courtesy of Michael Rosenfeld Gallery, LLC, New York, NY.

if into space, like a beautiful abstract gesture complementing the flourish of his left hand: this is actually the bottom of the stage curtain.

Stylistically, *Vaudeville* is the antithesis of the portraits that Alston created during this period, but its psychological content is just as strong. Here is a conflicted black entertainer who must perform in blackface to an audience that is probably white. He is onstage, frustrated, his anger showing through. He becomes at that moment Bill Robinson, Louis Armstrong, and every other black entertainer to walk onstage since those difficult days of the thirties. At the same time, he becomes every black man, including the artist, who ever felt that his life had to flout the white world's wishes. Hence, the abstraction of the figure lost against a white background takes on a new and deeper symbolism. The figure's ample size also suggests an immensity of talent, which could so easily descend into slapstick in the early twentieth century. Stereotypical imagery of blacks was rampant during the twenties and thirties, yet Alston, in this single image, forces us to ponder the man beneath the mask.

HARLEM HOSPITAL MURALS: "FORMING AN INTELLIGENT PART OF THE COMMUNITY"

In 1935, Charles Alston became the first black supervisor working for the WPA Federal Art Project in New York. At the same time that he was working on easel paintings, watercolors, and drawings—and teaching his various classes—he was awarded a federal commission to create murals for Harlem Hospital and to supervise other artists who would be creating other murals. Unknown to the artists who worked on WPA Project Number 1262, as it was classified, their efforts would soon become part of a cause célèbre within the Harlem community. Project artists included Vertis Hayes, Sara Murrell, Georgette Seabrooke, Fred Coleman, Morgan Smith, John Glenn, and James Yeargens. The responsibility for supervising these muralists was tremendous, and the task was one that Alston took seriously. In addition to coordinating all of the muralists at Harlem Hospital, Alston had to create and complete his own mural assignment. Alston's contribution, completed in 1936, was a diptych that takes a kaleidoscopic approach to a vast topic: the roots of modern medicine in the African American community. The two murals present a rich African past, as shown in *Magic in Medicine* (Plate 6), juxtaposed with the hope of a progressive American future, as shown in *Modern Medicine* (Plate 7). For Harlem Hospital, these works would serve as portals of entry into a culture rich with both ancient folk traditions and modern scientific training.

Harlem Hospital opened on April 18, 1887, as a leased three-story wood building at the foot of East 120th Street and the East River. From its inception, Harlem Hospital provided medical care for the poor, specifically for those living in the areas north of Central Park. Land at Lenox Avenue and 136th Street was acquired in 1900 for a larger facility that would accommodate the increasing population and rising demands for health services.[9] By 1915, with the influx of African Americans moving to Harlem from the South, more and more services were provided for black residents. In 1917, Harlem Hospital hired several African American nurses, prompting many white nurses to resign in protest. In 1920, Dr. Louis T. Wright became the first black physician to be employed at the hospital,

as a clinical assistant in the outpatient department. Aware of the hospital's history, the mural artists sought to create images that responded to and reflected the historical and cultural themes of both the hospital and the larger community.

Charles Alston was inspired by the work of Aaron Douglas, who had, only the year prior, raised the bar in public art when he created the mural series *Aspects of Negro Life* for the 135th Street Branch of the New York Public Library, also a WPA commission. Alston's diptych summarized his philosophy regarding the history of medicine as practiced by both African and African American people. Before starting the work, he conducted research into traditional African culture—music, art, food, natural healing—that existed long before African Americans started contributing to modern medicine in the early twentieth century. The two murals allowed him to synthesize his studies and his determination to share what he had learned. As a supervisor, Alston had to bridge the gap between the successful administration of the project and his own personal view of what the murals should look like. Under immense pressure to deliver the murals in their entirety without compromising their message, he saw it through without compromising his own artistic vision, a vision that demanded that he speak freely as a black artist.

In the panel *Magic in Medicine,* Alston promotes African culture and its more holistic approach to healing. In creating one of America's first public scenes of Africa, he was faced with a challenge: how to present an accurate, detailed depiction of African culture while being forced to rely on others' images and narratives, since he, like the other artists of the Harlem Renaissance, had not traveled to any part of that continent.

Magic in Medicine presents a multilayered scene against a mountainous terrain, with a huge moon in the background. In the left midground are huts, while in the center are three dancers in rapturous formation, with a large Fang sculpture to the left. This vignette in particular is reminiscent of Douglas' *African Dancers,* the first of four panels in his watershed *Aspects of Negro Life* series. The major presence of a Fang ancestral figure in Alston's mural speaks to his growing familiarity with African art, kindled by his early contact with Alain Locke. For artists such as Douglas and Alston, African sculpture and dance became crucial elements in their representations of Africa. Douglas recalled taking the subway with other artists downtown to the American Museum of Natural History to examine the sculptures in the museum's permanent collection; other artists, including Alston, had helped organize the exhibitions of African art put together by Dr. Locke.[10] Benefiting from such an unforgettable hands-on experience, Alston discovered the foundation for his monumental style in these African sculptures:

> Alain Locke came up here with an exhibition of African sculptures, masks, and what-not, for the Schomburg Collection. I went around there while he was arranging the exhibit, and this was the first time I'd seen any number of examples of African art. I was fascinated with them. And with Locke right there on the scene. I probably asked a million questions about them, and I had a chance to hold them and to feel them. And they have played a tremendous part in my work.[11]

Plate 6. *Magic in Medicine: Study for Harlem Hospital Mural, New York City,* 1936.

Graphite on paper, 16 3/4 x 13 1/2 in. Courtesy of Michael Rosenfeld Gallery, LLC, New York, NY.

Plate 7. *Modern Medicine: Study for Harlem Hospital Mural, New York City,* 1936.

Graphite on paper, 16 ³/₄ x 13 ¹/₂ in. Courtesy of Michael Rosenfeld Gallery, LLC, New York, NY.

From the midground, we move to the foreground of *Magic in Medicine*. In the left front corner, a group gathers around an ailing figure, attending to his illness, perhaps with herbs and traditional remedies. In the center is a tree trunk with a figure reaching forward with an extended hand. Down in the corner at the right, another figure kneels as if praying. What is striking in this work is the complexity of the interactions between people and nature, between the community and its land. Animals peer out of the scene and form a connecting bond between civilization and wilderness. The energy, the movement, the sense of a procession, create a strikingly accurate depiction of an Africa self-engaged and self-sufficient, with music and ceremony at the center of life. One senses too a pride of presentation, an unapologetic look at African culture; Alston saw no need to stereotype or exaggerate.

In the second panel, *Modern Medicine,* the artist offers a comprehensive and ambitious mapping of the contributions of African Americans to the field of medicine. In the panoramic scene, the microscope becomes the central arena of discovery around which other scientific efforts are displayed. On the left, surgeons ring a patient, while below a doctor talks to students or family members. Another doctor in a white laboratory coat stands on the right. Above the microscope is a bearded Greek, positioned like Moses with a rising sun behind him. Sheep and other animals appear below the figure to the right. Below the microscope, a woman holds an infant in her arms; the model for this figure was medical intern Dr. Myra Logan, who would later become Alston's wife.

Although all the sketches created by the seven artists commissioned for the Harlem Hospital mural work were approved by the Federal Art Project, four of the sketches met with the objections of the hospital superintendent, Lawrence T. Dermody, and the commissioner of hospitals, S. S. Goldwater. The artists were stunned to receive a letter dated February 13, 1936, from Lou Block, the project supervisor, rejecting the problematic sketches, including Alston's. The letter read in part:

> I regret to have to tell you that the mural projects for the Entrance Lobby to the new Women's Wing, Charles Alston designer, the Main Corridor in the Nurses Home, Vertis Hayes, designer, Children's Ward, Sara Murrell, designer, and the Nurses Pent House and Recreation Room, Georgette Seabrook[e], designer, have been rejected by the hospital authorities.
>
> The basic reason for the rejection is that the Harlem Hospital as a city institution should not be singled out because of its location in the city for the special treatment indicated in the mural designs, i.e., that the subject matter deals with various phases of Negro endeavor and community life.
>
> The artistic integrity of the work is not at all questioned and there is no reason why the group of artists in your charge should not be able to carry out mural projects in other city institutions.[12]

If hospital administrators and WPA authorities were expecting these talented black artists to simply pick up their palettes and await reassignment for their government wages, they were in for a rude awakening. As artist spokesperson and supervisor of the project, Charles Alston dug in his heels and protested with great eloquence. The son of Reverend Primus Alston was not about to back away from this cultural standoff. All of the late-night debates at 306, the compelling discussions regarding the differences between the art worlds of black and white New York, had prepared him for this day. The artists quickly organized. The Artists' Union and the Harlem Artists' Guild united to respond to what was regarded as an arbitrary, racist, out-of-hand dismissal of major works of art by serious artists, created very much in accord with the cultural desires of the community and the atmosphere of the Harlem Renaissance. The Artists' Union, a downtown liberal organization, joined the Harlem Hospital artists in their protest. A letter to mural artist Georgette Seabrooke from Martin Craig, executive secretary of the union, dated February 15, 1936, documents the concerns of the Artists' Union:

> Dear Miss Seabrooke:
>
> The Project Organization of WPA Art Project #1262 has voted to fight the arbitrary rejection of mural sketches for Harlem Hospital—on the grounds that the facts prove that such rejection has been arbitrary, that the formation of an all-Negro project by the administration is or tends to be an act of segregation, that the circumstances of rejection indicate definite discrimination.
>
> We therefore specially invite you to a meeting of the Project Organization on Tuesday, February 18th, 4:00 p.m. at 430 Sixth Avenue, N.Y.C., in order that your fight, which is our fight as well, may be fully coordinated.[13]

The Harlem Artists' Guild and the Artists' Union worked together in composing a four-page letter responding to the rejection of the murals. The letter stated in part:

> Although all racial groups are cared for in the hospital without discrimination or segregation, the very make-up of the community in which Harlem Hospital finds itself makes it an institution which caters more than any other similar institution in the city to a racial group. Furthermore, Negro doctors, if they are to serve their internships in New York City, are forced to do so in Harlem Hospital. Finally, except in the highest executive capacities, the entire nursing staff is Negro.
>
> Therefore, we feel that a group of artists, forming an intelligent part of the community, with a finger on the pulse of its life, have a perfect right and duty to state those things which affect the life, cultural interests and achievements of the people most vitally concerned.[14]

The artists soon pointed out that designs "containing no colored figures" created by white WPA artists for the boardroom in the hospital's new building were "readily approved by Mr. Dermody."[15] The artists sent copies of their letter to thirty-six organizations and individuals, including President Roosevelt, whose WPA programs initiated the mural projects; Mayor LaGuardia; the Manhattan Medical Society; the NAACP; the National Urban League; the Mayor's Commission on Conditions in Harlem; the Society of Mural Painters; and *Crisis, Opportunity,* and *Nation* magazines.[16] The letter garnered broad coverage by the press, including the *New York Times,* and federal project directors soon realized that black artists participating in these projects had very strong ideas about their murals. They would not passively accept an outsider's response to their works.

The hospital backed down and the artists were permitted to complete their original designs. For Alston, the fight could have been detrimental to his career, yet he held his ground. In this instance, he may have had something to prove: the administrators may have selected Alston to serve as chair of this project because of his elite education and the light hue of his skin. But they were sorely misinformed if they expected unthinking obedience. Their assumptions were thrown back at them as twenty-nine-year-old Alston's true grit was tested and the combined intelligence of the African American cultural activists of Harlem united. For Alston, it was the first milestone in a career of intellectual activism, advancing his determination to speak for, to represent, and to lead his people. Like his cousin Romare Bearden and the activist Adam Clayton Powell Jr., who would become one of the most powerful voices in Harlem, Alston chose to use his access to power and his political prowess as a means of opening doors for others. His dedication to the betterment of Harlem would endure. Curator and writer Corinne Jennings remembered Alston's later involvement in organizing boycotts to create jobs for black employees at white-owned establishments, such as Harlem restaurants and department stores.[17]

Before the Harlem Hospital murals were installed, Alston's *Magic in Medicine* and *Modern Medicine* were included in the exhibition "New Horizons in American Art" at the Museum of Modern Art.[18]

Travels to the South

Charles Alston's enduring emotional connection to his birthplace would later induce the artist to travel south as part of a project to document southern life. He was prepared to create a universal black subject matter that fused his family's native southern culture with the African American artistic movement of the North. A quick study, Alston had absorbed all these influences. He was moved by the folklife around him in Harlem, which gave that community its unique character. But as a man with southern roots, he was sensitive to that character as well and traveled to the Black Belt to learn more about the culture that was his birthright. Alston's journey was, in a sense, a pilgrimage leading him to greater self-knowledge, much as it would be for those African American artists who traveled south after him, including Jacob Lawrence and Elizabeth Catlett. For Alston, it was the journey that enabled him to appreciate the strength of the black family.

His first trip, funded by a 1938 Rosenwald Fellowship, led to a series of works based on photographs Alston took of the region's people. In these genre portraits ("I took hundreds of photographs," Alston once stated), he places a specific face upon the South. Alston traveled with Giles Hubert, a Farm Security Administration inspector who welcomed company on his inspections. Consequently, he had up-close and personal contact with families and communities: "I got into places—rural places—I couldn't possibly have gotten into. I'd come in khakis with a camera and they just took it for granted that I was part of the official setup."[19] Alston visited Alabama, Mississippi, Arkansas, the Carolinas, and Georgia. In Atlanta, Alston was hosted by President Rufus Clement of Atlanta University, who, through Hale Woodruff, provided Alston studio space on campus. Much later, in 1972, Alston would have one of his last exhibitions at Atlanta University.

Midnight Vigil, completed around 1936 (Plate 8), is thought by some to be a vignette created for the Harlem Hospital mural series. The scene is one of high drama: a group surrounds the bed of a family member who has just died or is about to die. In the interior of a dimly lit cabin, shadows play across wide plank walls while women raise their arms in anguish and supplication. A potbellied stove sits in front of the bed as the tragedy spills forth from the corner into the lamplit room. The painting's colors evoke the room's flickering light. Standing at the foot of the bed, a woman looks up and away from the other mourners as if deep in prayer. Near the bed, an elderly man sits on a chair with a slatted back, while a woman in a red bandana leans on the bed in abject grief. The light, shadows, and colors underscore the gravity of life's most mysterious passage. As in the *Magic in Medicine* sketch, a restraint of expression prevents the scene from becoming hackneyed.

In the late-1930s painting *Shade Chapman* (Plate 9), the titular figure peers from beneath his weathered hat with a glint in his eyes. He gazes back at the viewer (or artist) as if contemplating something someone has just said to him. The man's broad shoulders contrast with the sharp planes of his face. His face harbors a sense of questioning and suspicion, as if he is thinking actively about the immediate situation, on his guard against the unexpected attention bestowed on him by the artist. His black apron indicates that he is a laborer, skilled yet keenly focused on his tasks, aware of strangers but not that interested in having his portrait painted by a sophisticated New Yorker. The rough strength of Chapman's character is echoed in the rough brushstrokes of Alston's painting.

Tobacco Farmer (Plate 10), painted in 1940, takes a different approach to southern portraiture. Here Alston places a very young farmer within the context of his life and work. Standing in front of an open doorway, the farmer, with a serious yet youthful face, looks off in thought. He wears white overalls and a blue shirt, his face framed by the bulk of the gray barn, whose uneven lines slant like the uneven doorway opening. Rich green tones are scattered across the painting, from a grove of trees in the background to grass near the foreground that stretches into an open shed hung with drying tobacco. White clouds hover over the barn, and the land exudes a beauty and lushness partly blocked by the farm architecture. It is as if the young man, whose bright eyes stare forward and away from the scene, is boxed within a small space, unable to appreciate the beauty around him because of his never-ending duties as an American farmer.

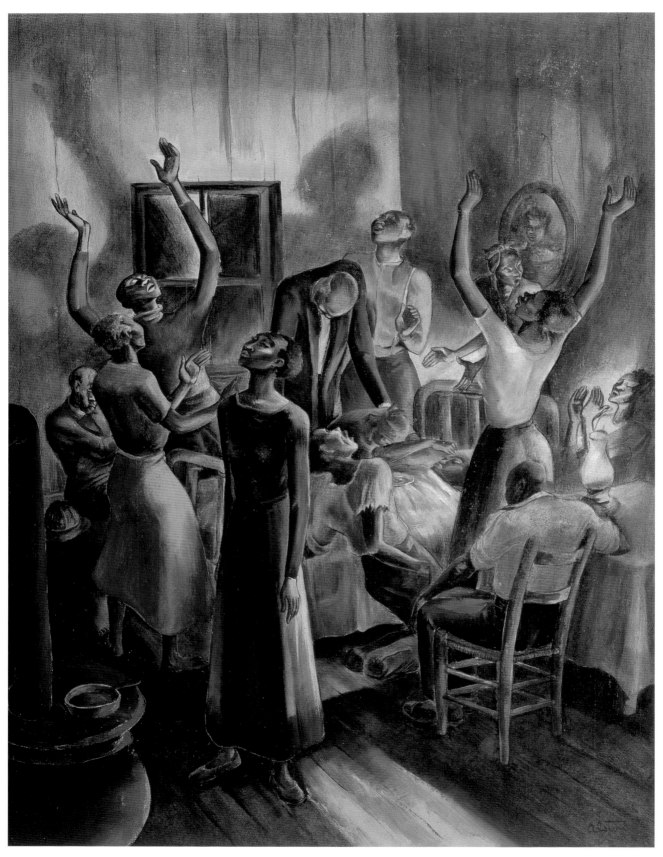

Plate 8. *Midnight Vigil*, c. 1936. Gouache on paper, 19 1/4 x 15 in. The Harmon and Harriet Kelley Foundation for the Arts.

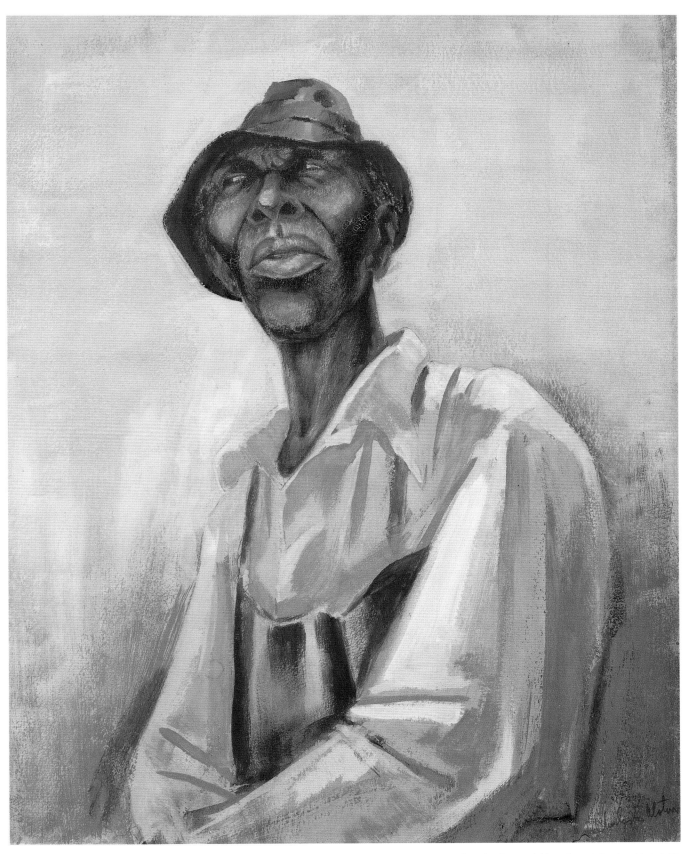

Plate 9. *Shade Chapman*, c. 1939. Gouache on paper, 19 x 15 in. Courtesy of Michael Rosenfeld Gallery, LLC, New York, NY.

Ruin (Plate 11) is completely bleak in its outlook. Alston had received a second Rosenwald Fellowship in 1940, and spent a great deal of time at Atlanta University. As the country crept toward war in 1941, he would have seen many signs of poverty throughout the South, yet this painting takes on a universality of expression. A woman sits at the edge of the floor of a ruined home, surrounded by the remnants of her life, facing the ruin and devastation of war or natural disaster. Although brown skinned, she could be from anywhere. She crouches dejectedly, a red sun blazing behind her, a single container on the ground next to her. The lifeless branches of a nearby tree reinforce the barrenness of the environment. The abstract quality of the work is accentuated by its composition: the entire scene "floats" on a brown circle of earth suspended against a darkened, cloudless, indigo sky. The posture of this figure conveys emotional power and character in the same manner as Jacob Lawrence's figures, particularly those in his Toussaint L'Ouverture and Harriet Tubman series, while calling to mind the plaintive forms of the mourning figures in Giotto's early Renaissance frescoes.

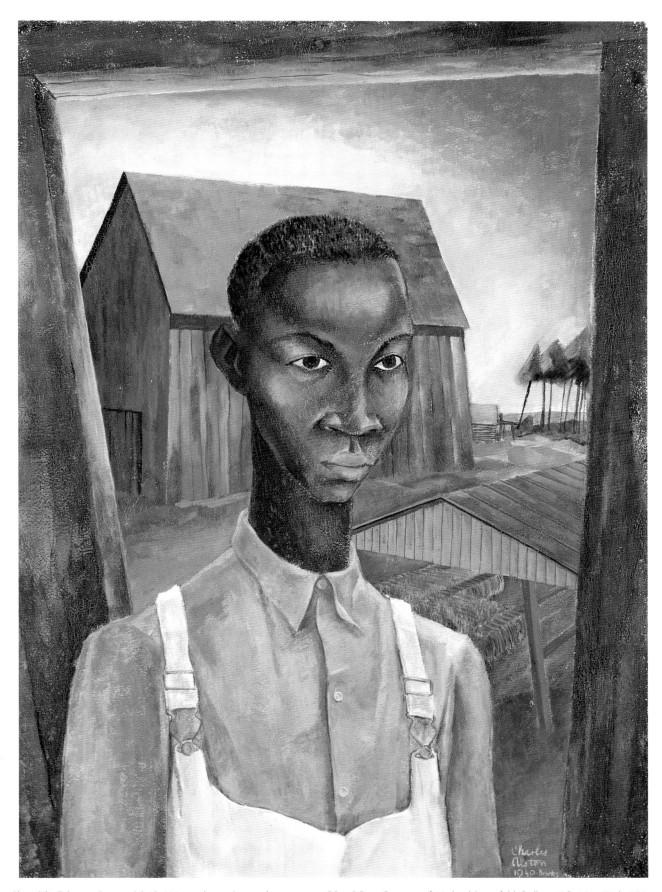

Plate 10. *Tobacco Farmer*, 1940. Watercolor and gouache on paper, 21 x 15 in. Courtesy of Michael Rosenfeld Gallery, LLC, New York, NY.

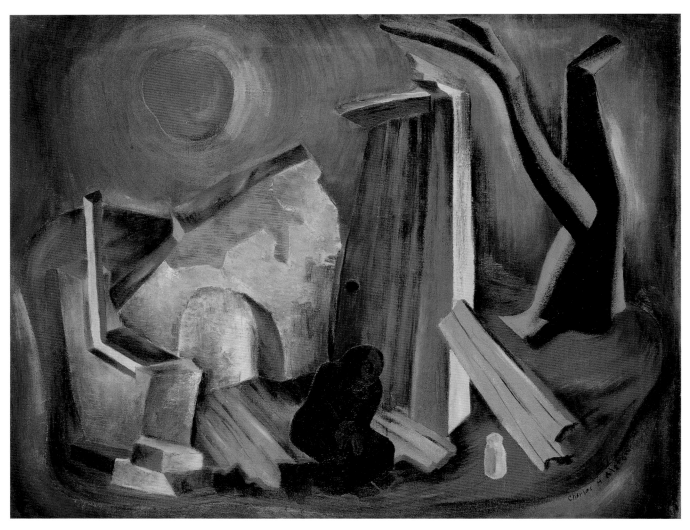

Plate 11. *Ruin*, 1941. Oil on canvas, 20 x 25 in. Courtesy of Michael Rosenfeld Gallery, LLC, New York, NY.

CHAPTER TWO ENDNOTES

1. The photograph by Marvin and Morgan Smith can be seen in the Photographs and Prints Division of the Schomburg Center for Research in Black Culture.

2. Romare Bearden and Harry Henderson, *A History of African-American Artists: From 1792 to the Present* (New York: Pantheon, 1993), p. 234.

3. Myron Schwartzman, *Romare Bearden: His Life and Art* (New York: Abrams, 1990), pp. 80–81.

4. Ibid., pp. 82, 84.

5. Ibid., p. 78.

6. Ibid.

7. Charles Alston, "Oral History Interview with Charles Alston," interview by Al Murray, October 19, 1968, transcript, Smithsonian Archives of American Art, p. 12.

8. Telephone interview with Harriet Kelley, Fall 2006.

9. The Schomburg Center for Research in Black Culture, "Harlem 1900–1940: Harlem Hospital," http://www.si.umich.edu/CHICO/Harlem/text/hospital.html.

10. Telephone interview with Aaron Douglas, November 1970.

11. Alston, "Oral History Interview (1968)."

12. "Harlem Hospital WPA—The Murals: Magic in Medicine," www.columbia.edu/cu/iraas/wpa/murals/index.html

13. Ibid.

14. Ibid.

15. Ibid.

16. Ibid.

17. Interview with Corrine Jennings, director, Kenkeleba Gallery, New York City, 2006.

18. Lemoine D. Pierce, "Charles Alston—An Appreciation," *The International Review of African American Art* 19, no. 4 (2004), p. 38.

19. Bearden and Henderson, *History of African-American Artists*, p. 264.

MODERN LIFE AND MODERN ART

A UNIQUE PARTNERSHIP

n 1940, Alston's acquaintance with the poet Archibald MacLeish helped him secure a position as staff artist with the Office of War Information and Public Relations. In an attempt to foster good-will with the black citizenry, the government had decided to publish a series of weekly illustrations highlighting the achievements of notable African Americans. Alston executed these drawings—of astronomer Benjamin Banneker, businessman C. C. Spaulding, boxer Joe Louis, and many oth-ers—for thirty-five dollars apiece. The series appeared in over two hundred black newspapers across the country.[1]

While working on the Harlem Hospital murals, Alston had become acquainted with Dr. Myra Adele Logan, an intern at the hospital. While he was in the army in 1942 and 1943, and stationed at Fort Huachuca in Arizona, Alston wrote to Logan, decorating the margins of his letters with sketches of desert cactus. (Interestingly, when Anna Alston Bearden saw early on that her son had a serious interest in art, she told him that his father had been something of an artist himself and had written her letters with small drawings in the margins.) Charles and Myra were married on April 8, 1944; their wedding picture shows Alston in his uniform.

Alston and Logan both had early exposure to art. Her parents both taught at Tuskegee Institute. Her father, Warren Logan, was Tuskegee's longtime treasurer, and her mother, Adele, the school's first librarian.[2] Myra's sis-ter Ruth Logan Roberts hosted a Harlem Renaissance salon at her house in the late twenties, just as Bessye Bearden, Romare Bearden's mother and Alston's aunt, had hosted a salon at her home. Author Dorothy West, who was at Columbia at the time, was a friend of the Logans. Alston was not a typical bohemian, but one who moved easily within the upper reaches of the black bourgeoisie. He was, as

Figure 9. Myra Logan and Charles Alston on their wedding day. Photograph courtesy of Aida Bearden Winters.

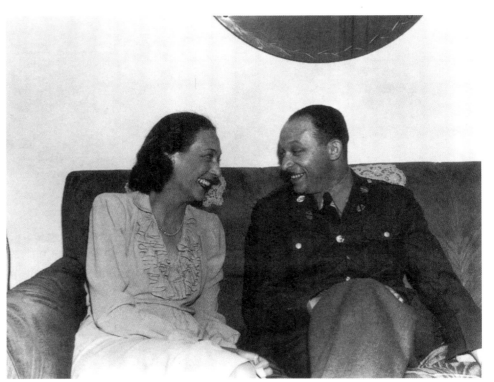

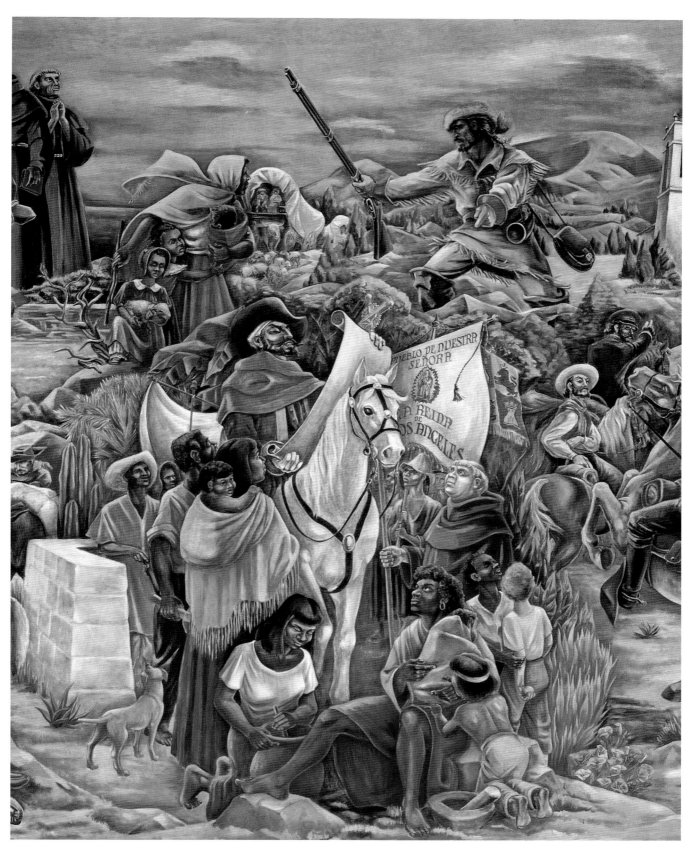

Plate 12. *The Negro in California History: Exploration and Colonization* (detail of Plate 13), 1948.

Jacob Lawrence said, a "college boy." The couple's individual achievements, varied interests, and similar backgrounds made for a unique partnership.

For each of Alston's accomplishments, there was an equally fascinating achievement in Myra Logan's life. Born in Tuskegee, Alabama, in 1908, she is considered a pioneer in the fields of civil rights and women's rights. Logan attended Atlanta University in Georgia, graduating at age nineteen in 1927 as valedictorian of her class. She earned her master's degree in psychology from Columbia University. Awarded the Walter Gray Crump Scholarship for Young Women, Logan used the award to attend New York Medical College.[3] In 1933, she earned her medical degree and began an internship at Harlem Hospital, where she also served her residency and ultimately became an associate surgeon. She was also a visiting surgeon at Sydenham Hospital. Throughout the early years of her medical career, Logan's mentor was Dr. Louis T. Wright.[4]

Logan conducted important research on new antibiotic drugs, such as aureomycin, and published her results in the *Archives of Surgery* and the *Journal of American Medical Surgery*. In 1943, Logan became the first female physician to perform open heart surgery; this was only the ninth such surgery ever completed. She was also a charter member of one of the first group practices in the nation, the Upper Manhattan Medical Group of the Health Insurance Plan; physicians from various specialties under one roof was an innovation at the time and is the norm today.[5]

The newlyweds lived in an apartment at 555 Edgecombe Avenue, an elegant building with a large contingent of Jewish residents. Alston had a spacious studio there. At the time of the Alstons' marriage, Edgecombe Avenue was undergoing changes akin to the gentrification occurring today in many older black urban neighborhoods. Down the street from the Alstons at 80 Edgecombe Avenue, A'Lelia Walker held gatherings much like those of her Dark Tower salon in the 1920s. Later to become an author and women's studies scholar, Myra Logan's niece Adele Logan Alexander and her family lived in number 555. She has vivid memories of visiting "Myra and Spinky" every Wednesday for dinner. As Alexander recalls, the urbane couple prepared her for college life by inviting her to their home for cosmopolitan conversation. Myra was an accomplished pianist, according to her niece.[6]

Alexander spent many hours in her uncle's studio during her childhood. She remembers Alston making silkscreened Christmas cards, and she learned about the process of blocking colors by observing and helping him. She recalls seeing his famous painting *Family* (Plate 17) on the big easel in his studio and watching him create terra-cotta sculpture. She also saw big hunks of wood in the studio, along with watercolors, Japanese pots and brushes, pen-and-ink drawings, and Alston's illustrations for *Malcolm MacBeth,* a children's book by John Storm published in 1946. The story recounts the adventures of a young Scottish boy as he moves across the hills of his countryside encountering the good and bad witches of the region. Alston's animated line drawings bring these fanciful stories to life and show the artist's ability to immerse himself in another culture and time, simply through his own imagination. Today the drawings have a classic illustrative style. Alexander remembers that when Alston designed the endpapers for Eudora Welty's 1946 novel *Delta Wedding,* he invited his young niece to add a fish swimming in a stream. The sensitivity and openness that made Alston such a good teacher were deeply appreciated by his niece.

Alexander also remembers her uncle as a wonderful and imaginative cook. New Year's Eve was always spent at home, and the meal had to be soul food—pig's feet and ribs—and champagne. Uncle Spinky would create tasty mushroom dishes that her brother, who disliked mushrooms, would actually enjoy. The Alstons were a progressive couple who adopted a flexible approach to domestic duties. As Alexander explains, "Myra was always working, so Spinky cooked."[7] They were one of those professional black couples who did not mind a nontraditional division of labor.

COMMERCIAL ENTERPRISES

As a commercial artist, Alston worked on book jackets, record covers, and magazines. In the 1930s and early 1940s, he contributed illustrations to such well-known publications as *Fortune, Collier's, Men's Wear, Mademoiselle,* and the *New Yorker.*[8] A responsible man, Alston wanted to earn a living as an artist even though his wife was a prominent surgeon. His skills guaranteed him steady work from the big New York publishing industry.

One prominent aspect of Alston's commercial work was his illustration of everyday New York life. Executed quickly and fluently, these drawings resemble excerpts from a visual diary, in which the ever-observant Alston recorded the many types of people out and about on the streets of New York City, from Harlem to the Bowery, the Upper East Side, and 34th Street. He had mastered the popular drawing style of the 1940s, which captured Americans' attitudes and urban energy through the posture and visual dialogue of the figure—sassy repartee insinuated by a quick pencil line, turn of the chin, or head thrown back. He obviously derived a certain level of satisfaction in creating these drawings, but ultimately it was not enough for him. More satisfying were his editorial cartoons, a venue explored by only a handful of African American artists over the years. These enabled him to express his shrewd and acerbic political opinions. But the strictly commercial work stifled Alston and in 1946, with his wife's support, he decided to give it up.

GOLDEN STATE MUTUAL MURALS

In the late 1940s, Charles Alston was invited by his longtime friend Hale Woodruff to work with him on a pair of murals that documented African American contributions to the West. Commissioned by Golden State Mutual Life Insurance Company, the project specifically required the artists to create a detailed visual narrative depicting the contributions of blacks to the settling of California. Golden State Mutual began as a small black-owned business in 1925, operating from an upstairs storefront on South Central Avenue near downtown Los Angeles. The company was founded to provide local African Americans with insurance because no other financial institution would. Today Golden State is licensed in twenty-two states and the District of Columbia.

Stepping into the role of history painters, Alston and Woodruff used this opportunity to do original research and to create an educational tool that would convey to young black people the richness of their African American heritage. Woodruff had already completed the famous *Amistad* murals—which focused on the slave revolt—for Talladega College, and he brought to the California project that same attention to detail and talent for interpreting little-known heroes and chapters of African American history. The murals created by these two artists are priceless

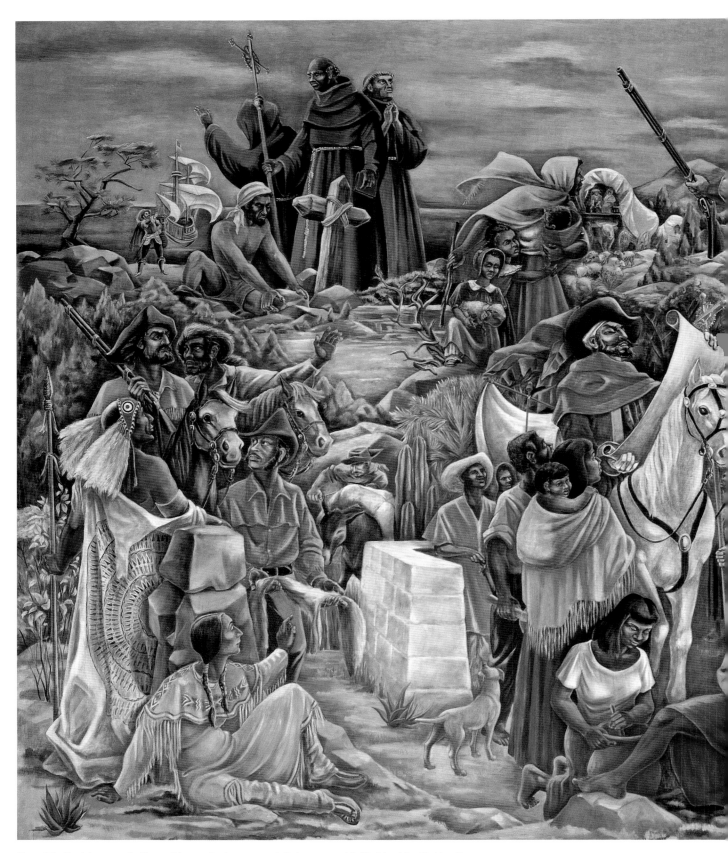

Plate 13. *The Negro in California History: Exploration and Colonization*, 1948. Mural for Golden State Mutual Life Insurance Company. Oil on canvas, approx. 111 x 197 in. Photograph by Brian Forrest.

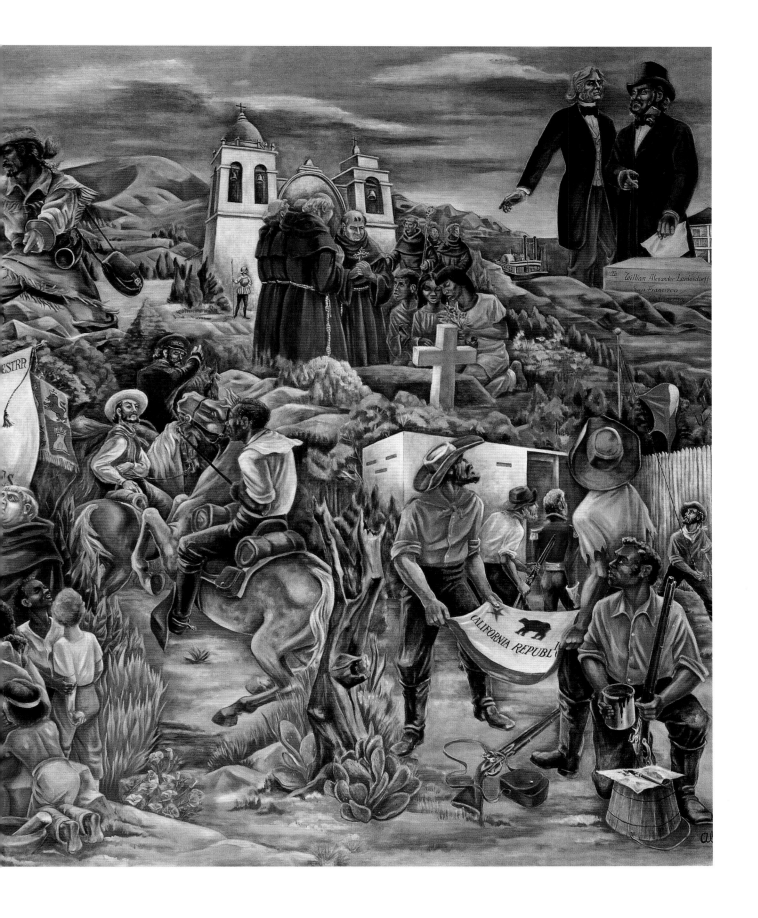

contributions to American narrative art. Unveiled in 1949, the two-paneled visual epic, *The Negro in California History,* comprises Alston's *Exploration and Colonization* and Woodruff's *Settlement and Development.*

Exploration and Colonization is a work of oil on canvas that covers approximately the period 1527 to 1850, portraying African Americans who played a significant role in California's settlement period after the arrival of Europeans. Among those pictured are ex-slave and philanthropist Biddy Mason, explorer James B. Beckwourth—who found a passable trail through the Rocky Mountains now named in his honor (Beckwourth Pass)—and merchant and civic leader William Leidesdorff. The artist's meticulous research into the subject resulted in a visual narrative rich with detailed vignettes, as opposed to the sweeping generalizations often seen in less successful murals. The two scenes sparkle with detail and drama, intriguing the casual viewer, the art lover, and the history buff. Woodruff's work picks up where Alston's leaves off, roughly 1850. With less focus on individual heroes, Woodruff depicts gold miners, Boulder Dam construction workers, and Pony Express riders. The murals, completed in 1949, remain in the interior lobby of the Golden State Mutual Headquarters, a building designed by the distinguished African American architect Paul Williams.

Alston and Woodruff worked on the Golden State murals in a huge rented space in New York, using ladders to reach the upper stretches of canvas. Adele Logan Alexander remembers visiting her uncle in that studio space and examining the huge works being produced. She recalls that the immense room received amazing light from the west.[9]

Visualizing California, wide open and beautiful, must have been a challenge for Alston, whose family had migrated not westward but from the South to the North in search of the promised land. The later movement of blacks from other parts of the country to California—the final trek—would have interested Alston immensely. While working on this project, the two artists maintained dialogues with prominent African Americans on the West Coast, including the founders of Golden State Mutual and Williams, who was the first black graduate in architecture from the University of Southern California. That a network of black businessmen could reach across a continent to find the talent to create these murals testifies to the vision of the company and the dedication of all involved. By spotlighting aspects of the black experience not found in most books of the time, the murals have increased public awareness of African Americans' contributions and of episodes in regional history that might otherwise have been forgotten.

Alston had been elected to the board of directors of the National Society of Mural Painters in 1943. Around the time of the Golden State Mutual mural project, he also completed murals for the American Museum of Natural History and the Abraham Lincoln High School in Brooklyn.

Not content to draw on his undergraduate training in art, Alston periodically took courses in New York from artists who he felt would enrich his base of learning. In the fall semester of 1945, for instance, he enrolled in a course in two-dimensional design with Alexander Kostellow at the Pratt Institute. Kostellow was known for his design theories, specifically regarding the flow of objects within a composition. He put forth the idea that objects flowed from left to right. African American illustrator George Ford was one of three black students enrolled at Pratt at the time. At age nineteen, he was keenly aware of the deference that his teacher Kostellow showed Alston.

Referring to him as "Charlie," Kostellow made it a point to inform the class that they were in the presence of a major American talent. According to Ford, Alston came to class dressed in his tweeds, projecting an "imperial presence" while concentrating on the exercises provided by the instructor. The young artist recalls being impressed by Alston's concentration, the dispatch with which he completed the designs in class, and the fact that his renderings were created in color. For the students, many of whom were veterans just returning from the war, it was thrilling to witness two senior artists exchanging ideas in the Pratt classroom.[10]

This kind of investment paid off for Alston, for in his continuous exploration of the changing art scene and his determination to remain at the cutting edge of art creativity, he was able to hone his craft and push himself forward. Consequently he came to the attention of those at the John Heller Gallery and had his first solo exhibition in 1953, confirming that his move from the commercial arena was the right decision. The gallery was a major force in the New York art scene, representing artists such as Arthur Jensen and Roy Lichtenstein. Alston showed consistently with Heller, with five exhibitions from 1953 through 1958.

TEACHING IN MAINSTREAM INSTITUTIONS

In the 1950s Alston began to knock down barriers at mainstream art institutions. He was invited to teach at the Art Students League in 1950—becoming its first African American instructor—and he remained on the faculty there until 1971. Similarly, Hale Woodruff accepted a position at New York University, and moved from Atlanta, where he had been teaching at Atlanta University.

The Art Students League had been founded by a group of students in 1875 to "maintain a school of art which will give thorough instruction in Drawing, Painting and Sculpture and cultivate a fraternal spirit among art students."[11] Located in the historic American Fine Arts Society Building at 215 West 57th Street, the League was organized as a democratic association that had no requirements regarding previous training. In the 1957–1958 course catalog, instructors are listed alphabetically, with Alston first. Other distinguished artists at the League during the period included George Grosz, Vaclav Vytlacil, and William Zorach.[12]

Dallas artist Jean Lacy studied with Alston at the Art Students League during the summer of 1957. She took his course in life drawing, painting, and composition and recalls that the huge class had almost one hundred students "packed in like sardines." Lacy had come up from Washington, DC, specifically to study with Alston, whom she had learned about through her family's copy of the book *The New Negro* by Alain Locke. Alston was the only African American faculty member at the Art Students League at the time. What Lacy remembers about Alston more than anything was his accessibility. Even in a class that was so crowded, he found the time to address the work of each student on a regular basis, moving through the room to offer comments and suggestions. He encouraged her in her art and suggested that she try to study as much as she could in New York, where there was such a wealth of artistic talent, especially among African Americans.[13]

The school was long regarded as progressive, so it is not surprising that the administrators hired a black instructor. They held Alston in high regard, as is obvious from a biography in the school catalog:

Mr. Alston brings to the League an impressive record as sculptor, muralist, easel painter, illustrator and teacher. . . . Among the students he has taught privately are Romare Bearden and Jacob Lawrence, both of whom distinguished themselves early in their respective careers. His works are in the Metropolitan Museum, the Whitney Museum and the collections of the International Business Machines and others. . . .[14]

If one considers the fact that in the South the mid-1950s represented the beginning of the dismantling of segregation policies within public schools, it would seem fitting that a liberal art school would be one of the first to accept African American students and faculty. Other mainstream educational institutions also pursued Alston. In 1956, he became the first African American art instructor at the Museum of Modern Art, where he taught for a year. Alston's teaching career peaked just at the point when arts institutions began to open their doors in an effort to reclaim their liberal roots, placing him at the juncture of progress and change in the American art world. Prejudice was not often spoken of publicly in the arts, as if somehow free-spirited creativity warded off racism. But only artists with the ammunition of experience and talent could cross the bridge between the uptown cultural center of Harlem and the downtown center of artistic commerce governed by commercial galleries. Alston was one of the first to cross that bridge.

After teaching for a year at the Museum of Modern Art, Alston was asked to travel to Belgium on a program sponsored by the museum and the State Department, to help coordinate a children's creative center at the Brussels World's Fair. This center would become the model for the Children's Art Fair in New York. In 1958, Alston received a grant from the National Institute of Arts and Letters, and he was elected a member of the American Academy of Arts and Letters.

CREATING ART IN THE FIFTIES

Charles Alston is known for—and has even been criticized for—the variety of the styles and media in his art. No period expresses his propensity for change and exploration better than the 1950s, when the artist sought to fully plumb the depths of his expressiveness.

Immediately following his journeys south, Alston began working on his family series. In paintings from the 1940s such as *Untitled (Portrait of a Girl)* and *Untitled (Portrait of a Boy)*, Alston focused on a strength of presence as represented in the sharp gazes of his young subjects, underscored by the angularity of their facial features. This reference to African sculptural form is the artist's way of combining figurative work with his interest in African art. In *Portrait of a Girl* (Plate 14), the brushstrokes that constitute her blouse, arms, and hands have become looser, and the zones of color in the background foreshadow later works in his family and blues series. In *Portrait of a Boy* (Plate 15), the artist seems as interested in depicting the cubistic composition of the city seen from the window as he is in showing the angularity of the boy's face. In a subtle way, the angular spareness of the boy's face and the rectangular forms of the wall and window reinforce one another. In another painting, *Head of a Girl* (Plate 16), a girl is shown in profile staring intently into the distance.[15] A simple Peter Pan collar frames her long neck, and her hair is pulled back. The work, focusing on the girl's character, is reminiscent of the earlier *Girl in a Red Dress*.

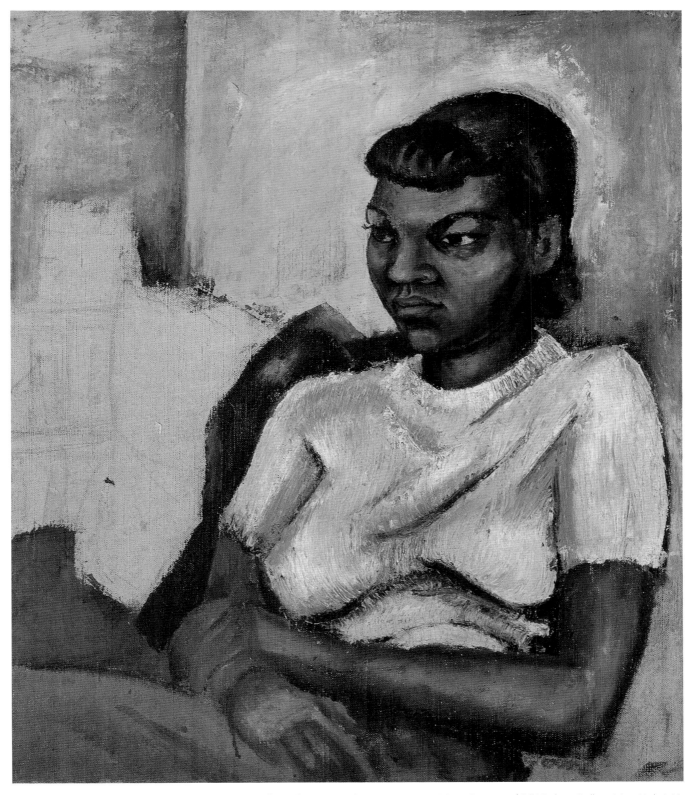

Plate 14. *Untitled (Portrait of a Girl)*, 1940s. Oil on canvas, 24 x 20 in. Courtesy of Bill Hodges Gallery, New York, NY.

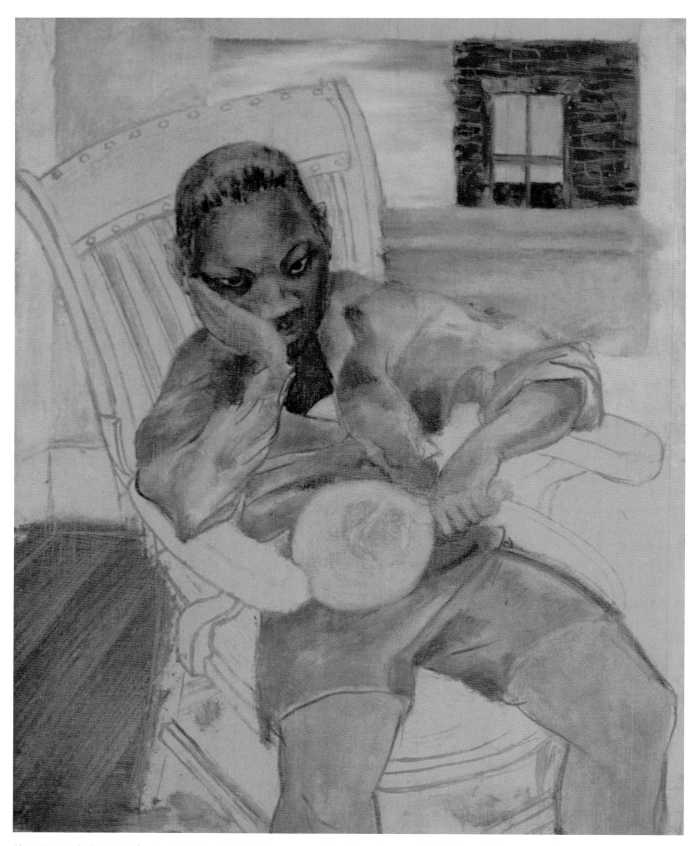

Plate 15. *Untitled (Portrait of a Boy)*, 1940s–1950s. Oil on canvas, 20 x 16 in. Courtesy of Bill Hodges Gallery, New York, NY.

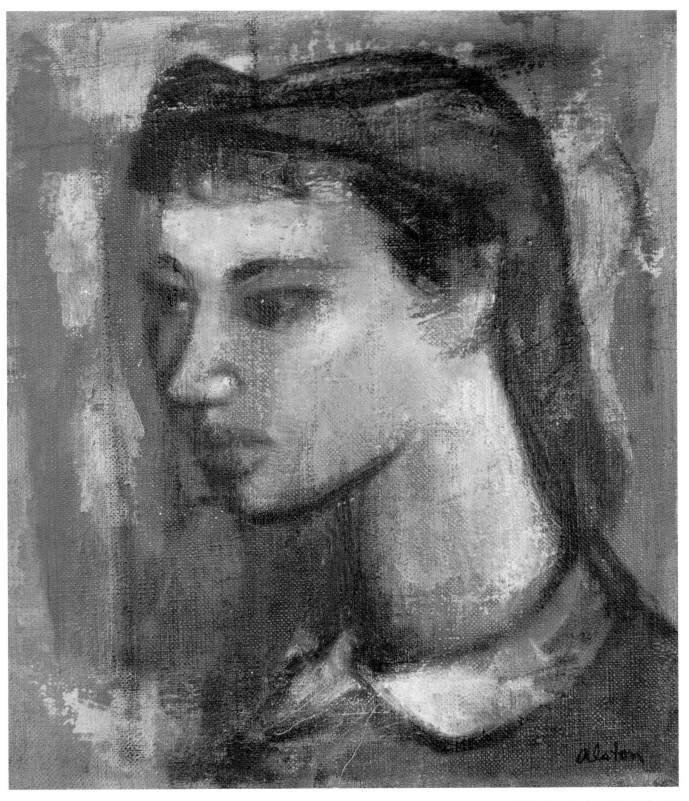

Plate 16. *Head of a Girl*, 1955. Oil on canvas, 12 ⅛ x 10 in. Courtesy of Bill Hodges Gallery, New York, NY.

In later works from the family series, combinations of figures become powerful yet organic compositions that are at once testimony to Alston's awareness of the spiritual symbolism of the black family and pure expressions of a visual synthesis of form and color. Alston was committed to portraying the effects of the injustices and indignities suffered by African Americans. At the same time, he was continually exploring new approaches to color, space, and form in his paintings. This duality stands out in Alston's midcentury paintings, and his foremost challenge was to maintain a balance between these two impulses. The family series was the ideal field for working out this tension.

When asked why his family groups are often faceless, the artist replied that such is the way white America views blacks. Although Alston's comment may stem from personal experience, these paintings represent much more than a response to whites' misperception of blacks. Their simple yet monumental composition evokes a sense of calm and enduring strength. The massiveness of the forms, especially those of the females, depends on the same visual vocabulary that informs the sculptures and prints of Elizabeth Catlett. Alston's works are marked by a deliberate simplicity of place, a universality, and an undeniable evocation of Paul Laurence Dunbar's famous poem "We Wear the Mask." The featureless images call to mind the second stanza of the poem:

> Why should the world be over-wise,
> In counting all our tears and sighs?
> Nay, let them only see us, while
> We wear the mask[16]

A punch of color also characterizes these paintings. Much like Cézanne, but with real volume, Alston defines his forms by color—not color laid over the form, but color that the form absorbs and then projects from within. The artist understands the importance of color to African Americans and how individuals use color to define themselves. The solidity of the figures, coupled with a thoughtfulness of gaze, gives Alston's family paintings dignity, inward energy, and depth.

In perhaps the artist's most famous painting, *Family* (Plate 17), the parents look inward—the woman seated and the man standing—while the children have their own separate complexity, more difficult for us to discern. The mother wears blue and sits quietly with her hands folded; blue and white frame her head like a square halo. The posture of the father is stately. The children seem to project more hopefulness: the girl motions to her brother, who holds a red ball in his hand—a symbol of play, freedom, childhood innocence, and life without the burdens facing his parents. The girl also faces away from the viewer, suggesting internal movement. Throughout the painting is the push and pull of picture plane that made Cézanne so revolutionary. The whitewash around the figures evokes the clapboard of old southern houses. The remarkable success of *Family* lies in its masterly combination of these visual elements, which work in turn to symbolize the strength of family, in particular, the African American family. The absence of careful delineation in the faces lends a greater universality to the work.

In *Family Group* (Plate 18), painted around 1950, Alston uses gray and ochre tones to combine the parents and a son as a unit. The family members are connected to create a geometric composition, like

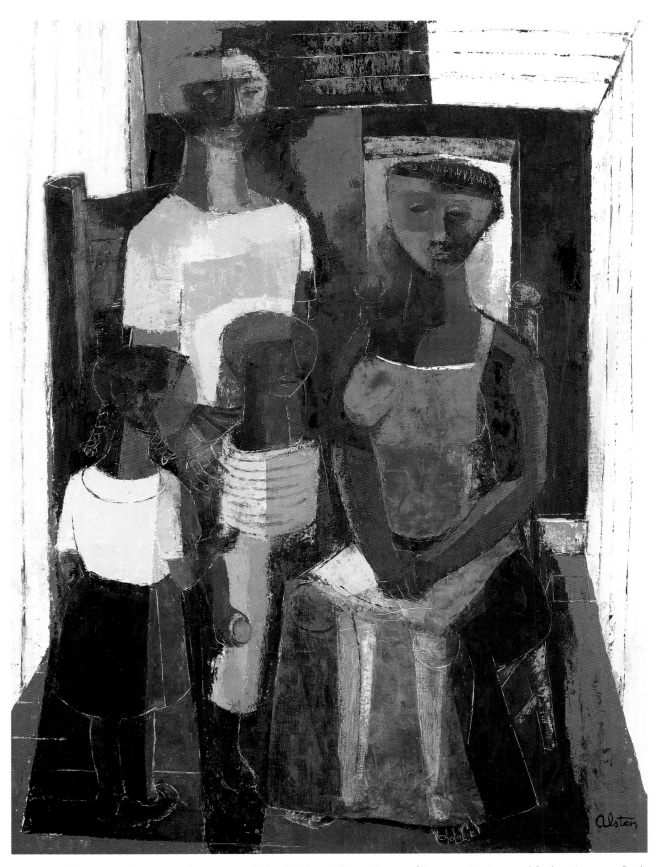

Plate 17. *Family*, 1955. Oil on canvas, 48 1/4 x 35 3/4 in. Whitney Museum of American Art; Artists and Students Assistance Fund.

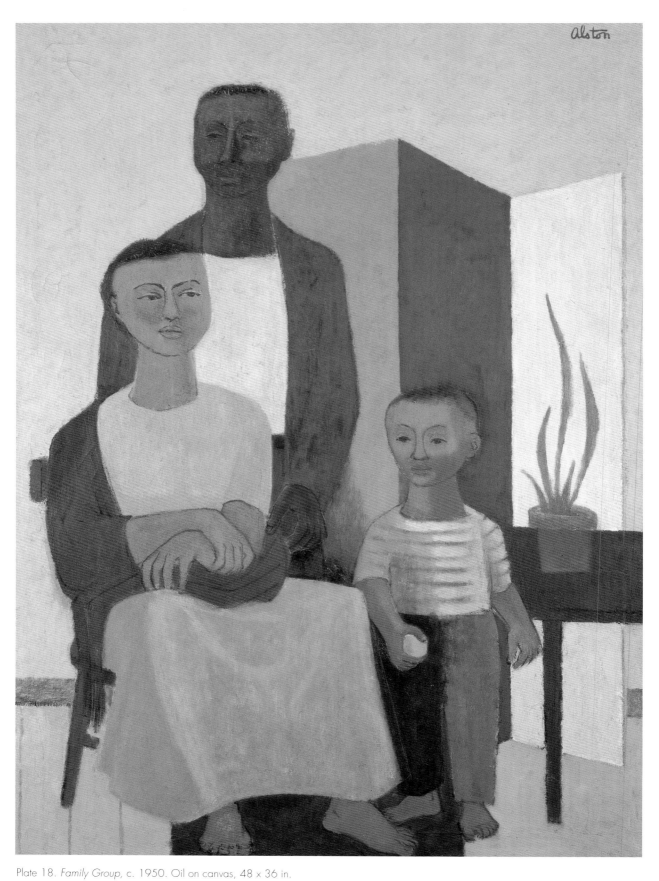

Plate 18. *Family Group*, c. 1950. Oil on canvas, 48 x 36 in.

Collection of John Axelrod. Courtesy of Michael Rosenfeld Gallery LLC, New York, NY.

interlocking pieces in a large puzzle. The mother—seated, barefoot, and dressed in gray—has her arms folded in her lap and holds a red shawl. Behind her stands her husband, the father, in a collarless shirt and work-worn clothing, his arm extended toward the woman's side. The child, also barefoot, holds a ball in his hand and stands close to his mother's knee. The mother looks outward and inward simultaneously, while the father has the slightest smile upon his face. The young boy has a gaze that is simple and direct. The folding screen in the background echoes the family trinity with its three panels in gray, black, and off-white. Behind the child sits a plant resembling a mother-in-law's tongue, a succulent often found in southern households. The tall plant with its swordlike leaves reaches upward for sunlight, suggesting life and growth. Its pyramidal shape mirrors that of the family: the central leaf, like the father, stands tall and strong in the center, while the newer leaves sprout up at the sides, like energetic children. The earth tones help integrate all the elements. This is certainly one of the paintings inspired by Alston's travels south.

Alston's work during this period is characterized by his reductive use of form combined with a sun-hued, Kleelike palette. In *Adam and Eve* (Plate 19), the couple stands together, Eve dressed in a skirt and no top, Adam in shirt and slacks. Both figures, depicted like cylindrical sculptures, appear against asymmetrical zones of color, dominated by orange and rust. Between the first couple, on a platform, is the apple, set on a platter. There is a sense of resignation and sadness about the work, despite its seeming simplicity.

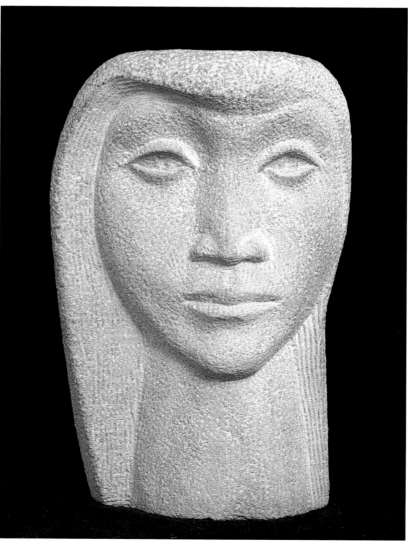

Figure 10. *Head of a Woman*, 1957. Carved granite, 13 1/2 x 8 1/2 x 4 in. Courtesy of Michael Rosenfeld Gallery, LLC, New York, NY.

Very modern in its feeling, *Standing Woman* (Plate 20) is marked by the same kind of geometric formality, with rectangular wedges of color shaping the composition. The woman's arms enclose another square zone of color.

Alston moved into a new phase at this point, for he simultaneously adopted a similarly reductive and modern approach to sculpture, where facial features were suggested rather than fully formulated in three dimensions, as in his portrait bust *Head of a Woman* (Figure 10). Similarly, *Portrait of Girl with Ponytail* (Plate 21) is a flat composition, the profile of the girl (Adele Logan Alexander) with her dark hair pulled back and her black leotard emphasizing the planar forms of the painting.

The artist began a series of ink-wash drawings of women during the same period. Lush with stained color and the unleashed linear

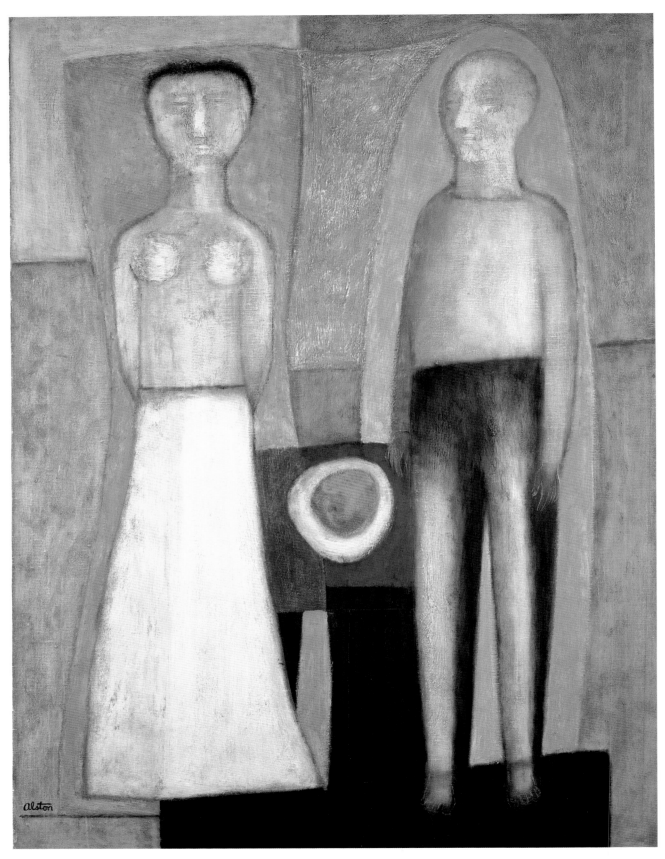

Plate 19. *Adam and Eve,* c. 1954. Oil on canvas, 40 x 30 in. Courtesy of Michael Rosenfeld Gallery, LLC, New York, NY.

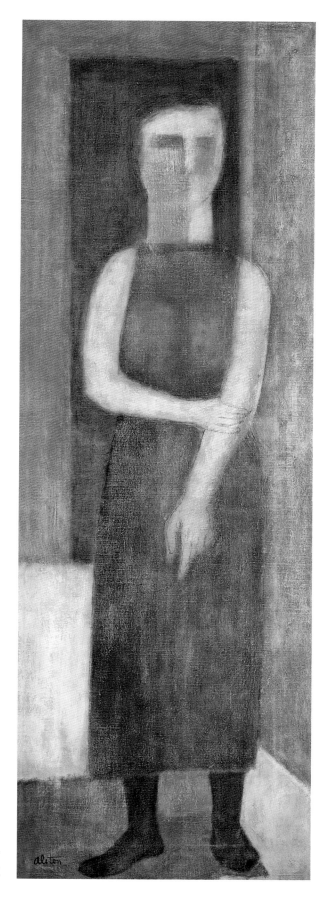

Plate 20. *Standing Woman*, c. 1956. Oil on canvas, 36 x 12 in.
Courtesy of Michael Rosenfeld Gallery, LLC, New York, NY.

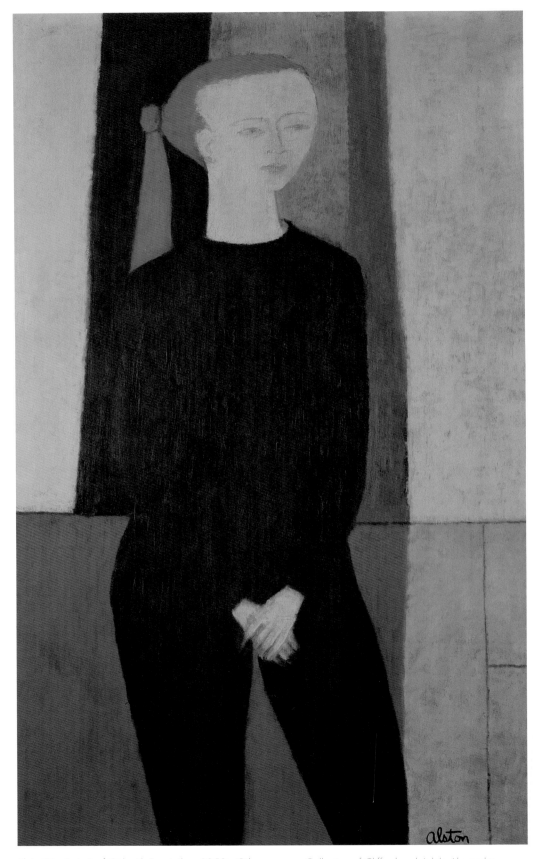

Plate 21. *Portrait of Girl with Ponytail*, c. 1950s. Oil on canvas. Collection of Clifford and Adele Alexander.

energy of his pen, works such as the 1955 *Portrait of a Woman* (Plate 22) are inspiring in their fluidity and saturated surfaces. Here he creates a flat surface while simultaneously adding, through the haze of facial expressions, a density and depth to the work that make it engaging and monumental.

In *Bus Station* (Plate 23), painted in the mid-1950s, Alston employed his new sense of reductive zoning to create a feeling of stasis—the same waiting, resigned quality that characterizes the earlier *Man Seated with Travel Bag. Bus Station* depicts a couple seated together on a bench, waiting for their bus to be called. The man holds a paper in his hand, while the woman holds her purse. The clock on the wall has been cut off by the edge of the picture plane, banishing any sense of time; the couple know only that they must endure the wait, the delay, the lack of information. The presence of the figures is a function of the brilliance of their colors. The man's pink shirt contrasts with his dark jacket and picks up a similar tone in the woman's purse. The pink shirt and handbag, orange-rust trousers, and deep blue of the woman's dress create a grid, a balanced patchwork of color, placed in front of vertically slatted barriers, producing a geometric framework. Their deep skin tones enhance the rich palette.

In contrast with the movement inherent in Alston's early works, such as *Midnight Vigil* and his murals of the 1930s, *Bus Station* has a stillness that commands the picture plane. This quality seems especially pronounced in comparison with Alston's drawings, which typically convey a surge of energy. In his illustrations of New York life, figures dash across streets, dance, sing, exchange words, and proselytize—all depicted with bold, sweeping strokes that mirror the hubbub of the city. His paintings, however, tend to express a different energy, one that is internal.

Just as Alston was especially interested in the black family, so too was he determined to express his love and respect for the genius of black musicians in visual form. Like other artists before and after, from Archibald Motley and Jacob Lawrence to photographer Roy DeCarava, Alston was inspired, indeed almost obsessed by the genius of music that surrounded him. In his recorded interviews for the Smithsonian with Albert Murray and Harlan Phillips, Alston's deep appreciation of black music is evident and his active interest in supporting artists such as Bessie Smith is equally apparent. Thus it is no surprise that Alston dedicated so much of his time to the interpretation of the lives and expressive personalities of musicians.

In *Blues Singer #4* (Plate 24), a female singer appears onstage wearing a white flower at her shoulder. Her bearing, her bigness, and the sweeping movement of her body are all conveyed and underscored by an audacious red dress.

As in *Girl in a Red Dress,* Alston used the color red to define the subject's personality. In both paintings, red imparts a strength and assertiveness to the wearer. The singer could be Bessie Smith, for as Alston noted, "I used to sit in Bessie Smith's rumble seat when she was going to record. I've got a sketchbook full of drawings of Bessie recording with Jack Teagarden and Chu Berry."[17] Whether or not she is Bessie Smith, the painting was no doubt inspired by singers the artist heard during his many nights out in Harlem, listening to live music with Romare Bearden and others.

The woman's face in *Blues Singer,* so open and youthful, so excited, belies her commanding frame. The cubistic background reinforces her solidity. She wears earrings and a bracelet in addition to her corsage. The little gap between her teeth is a small but brilliant detail, making her

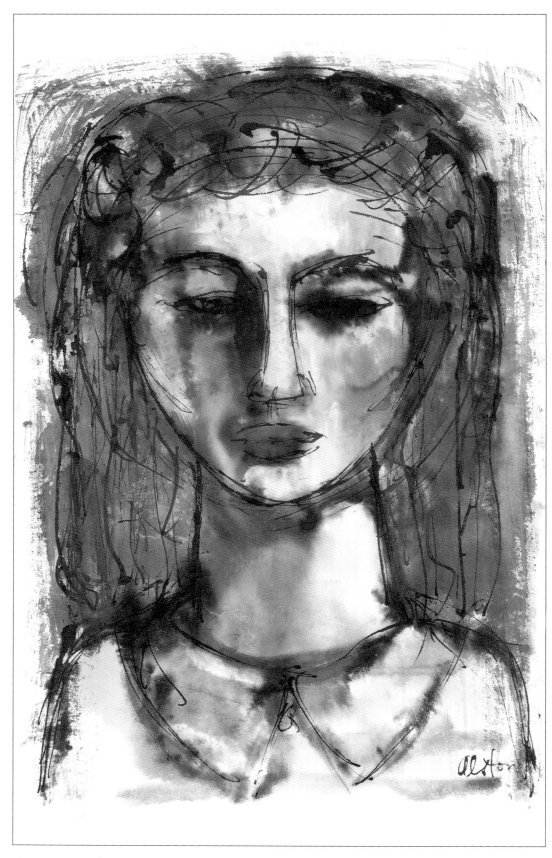

Plate 22. *Portrait of a Woman*, c.1955. Ink, wash, and watercolor on paper, 15½ x 11 in.

Courtesy of Bill Hodges Gallery, New York, NY.

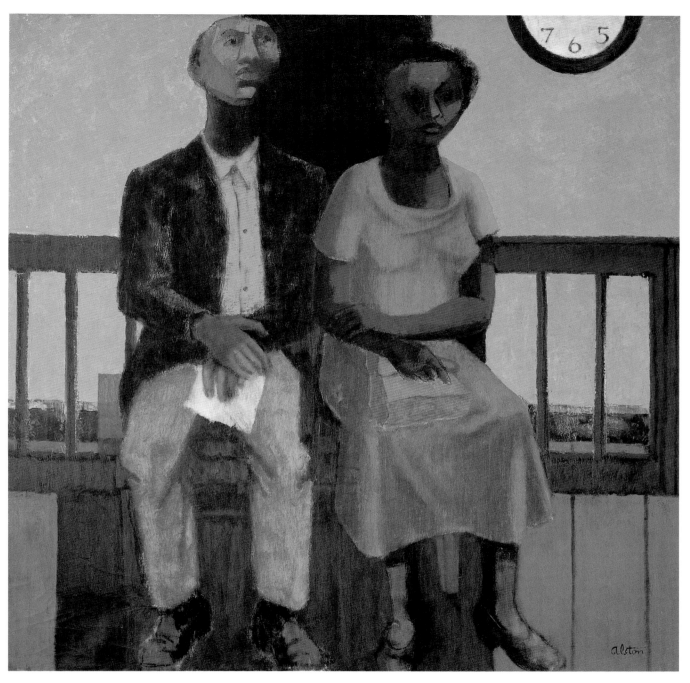

Plate 23. *Bus Station*, c. 1950s. Oil on canvas, 40 x 40 in. Collection of Clifford and Adele Alexander.

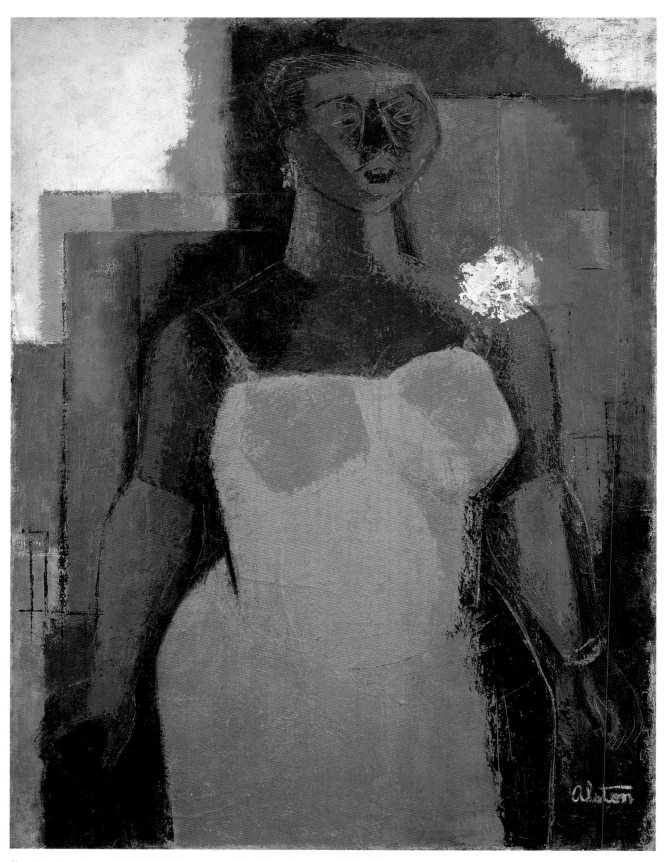

Plate 24. *Blues Singer #4*, 1955. Oil on canvas, 40 x 30 in. Courtesy of Kenkeleba House.

Plate 26. *Harlem at Night*, 1948. Oil on canvas, 28 x 38 in. Private collection.

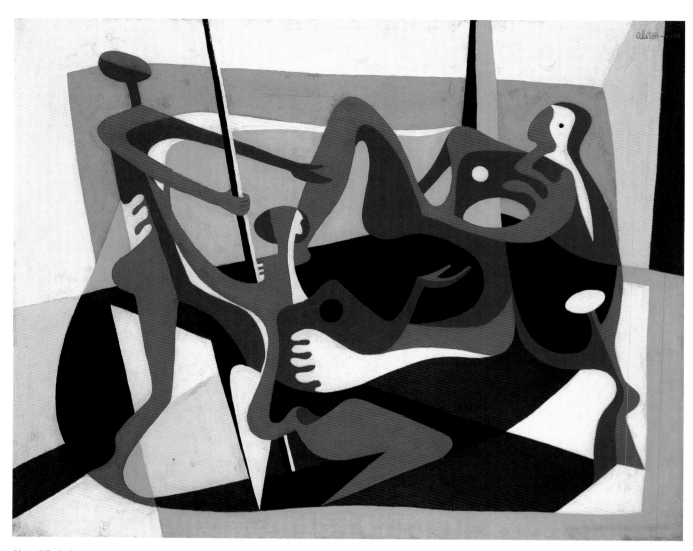

Plate 27. *Palavar #1*, 1946. Oil on canvas, 24 x 30 in. Courtesy of Michael Rosenfeld Gallery, LLC, New York, NY.

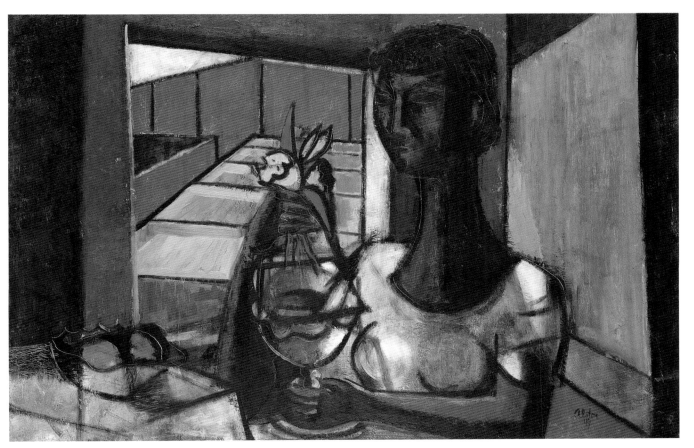

Plate 28. *Woman with Flowers*, 1949. Oil on masonite, 24 x 30 in. Courtesy of Michael Rosenfeld Gallery, LLC, New York, NY.

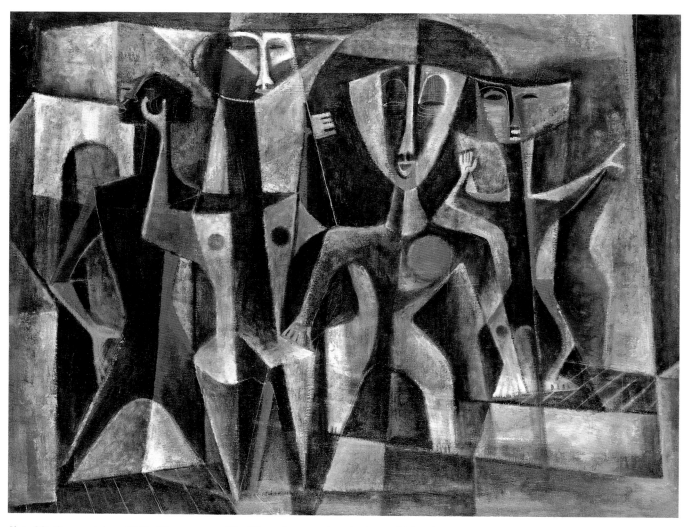

Plate 29. *Ceremonial*, c. 1950. Oil on canvas, 28 x 36 in. Courtesy of Michael Rosenfeld Gallery, LLC, New York, NY.

Fusing abstract and figural styles, *Symbol* (Plate 33) suggests the horrific scenes of Picasso's *Guernica,* a work that Alston greatly admired. Beneath a full moon, the aggressive predator, defined by angular and geometric elements, stands above a sacrificial bird, holding in his left hand a piercing weapon while howling to the universe. The result of this intense geometry is an image of unsettling emotion and dark discomfort. In an abstract work of the late 1950s (Plate 34), Alston created a mural study composed of interpenetrating angles and arches of color overlaid with thick, black lines. A wash of orange and blue lies beneath the abstract segments of color.

Charles Alston was always interested in depicting society as a whole and the interaction of the nuclear family within a larger community. The 1950s enabled him to explore these themes. In a mural study of about 1958 (Plate 35), he set down in vibrant colors vignettes of people harvesting food, holding discussions, and interacting as families, with children playing and a couple courting while a cityscape with a bridge highlights the background. In a 1950s pastel study (Plate 36), groups work together at what could be a community center: people of different nationalities stand together with their luggage, a mother holds a baby, a group in discussion sits at a table stacked with books. In the background, a man stands at a podium with an American flag behind him, and another man writes notes about the Constitution on a blackboard. Outdoors, laborers are busy at work.

A final painting of the decade, *Walking* (Plate 39), heralds the era immediately to come—the 1960s and the civil rights movement. Alston was inspired by the bus boycott in Montgomery, Alabama, and created the painting as a symbol of the surge of energy among African Americans to organize in their struggle for full equality. Two studies for the painting (Plates 37 and 38) show men, women, and children marching together as a single force across the picture plane. In one study, a deep blue sky is punctuated by a crescent of sun partially covered by the moon in eclipse. In a second study, there is no great eclipse in the sky, but behind the surge of movement of the people a great rush of light modulates from yellow-white to dark blue, as if a series of comets were moving across the sky. In each study, a single woman stands to the side as a small group looks on from the background. In the final painting, there is much more emphasis on the configuration of the group. The figures in the front are larger and appear even more determined, with their heads raised. The sky is not such an integral part of the work, receding into the background while the people walking appear to be moving forward out of the picture plane. Alston described what he was feeling when he created the work: "The idea of a march was growing. . . . It was in the air . . . and this painting just came. I called it *Walking* on purpose. It wasn't the militancy that you saw later. It was a very definite walk—not going back, no hesitation."[18]

Plate 30. *Untitled (Arrangement: Ochre and Gray)*, 1958. Oil on canvas, 40 x 48 in. Courtesy of Bill Hodges Gallery, New York, NY.

Plate 31. *Untitled (Still Life with Eggplant)*, 1961. Oil on canvas, 30 x 50 in. Courtesy of Bill Hodges Gallery, New York, NY.

Plate 32. *Untitled*, 1950s. Oil on canvas. Collection of Clifford and Adele Alexander.

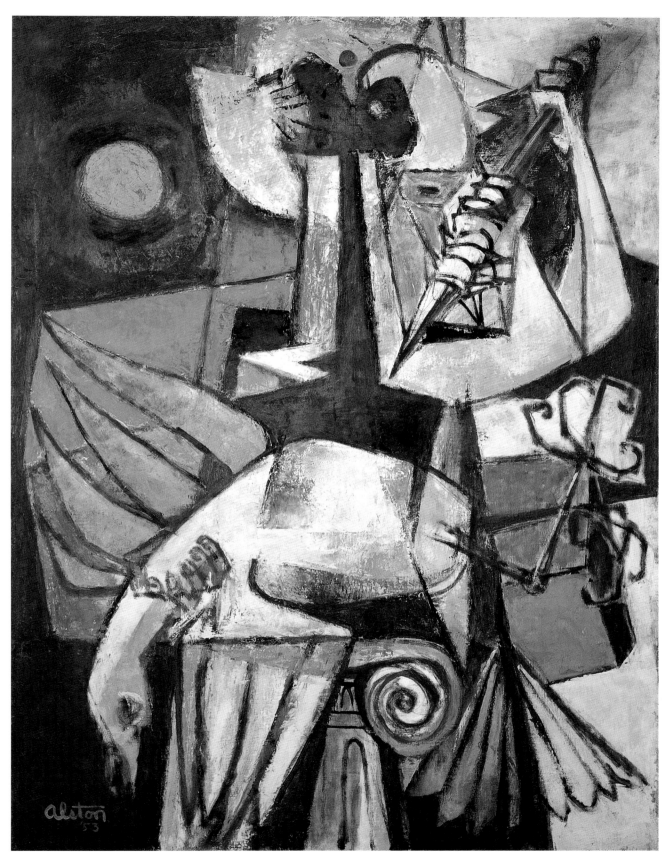

Plate 33. *Symbol*, 1953. Oil on canvas, 48 x 36 in. Courtesy of Bill Hodges Gallery, New York, NY.

Plate 34. *Untitled (Study for Mural)*, 1950s. Tempera on vellum, 11 ³/₁₆ x 36 in. Courtesy of Bill Hodges Gallery, New York, NY.

Plate 35. *Untitled (Study for Mural)*, c. 1958. Oil and pastel on transparent paper, 9 ⅝ x 18 ¾ in. Courtesy of Bill Hodges Gallery, New York, NY.

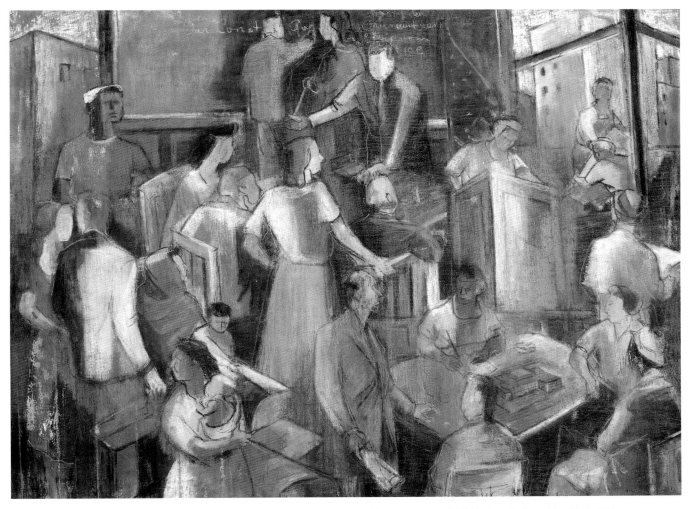

Plate 36. *Untitled (Community Center Scene)*, 1950s. Pastel on canvas, 30 x 39 ½ in. Courtesy of Bill Hodges Gallery, New York, NY.

Plate 37. *Untitled (Study for "Walking")*, c.1958. Gouache on card stock, 10 ¼ x 18 in. Courtesy of Bill Hodges Gallery, New York, NY.

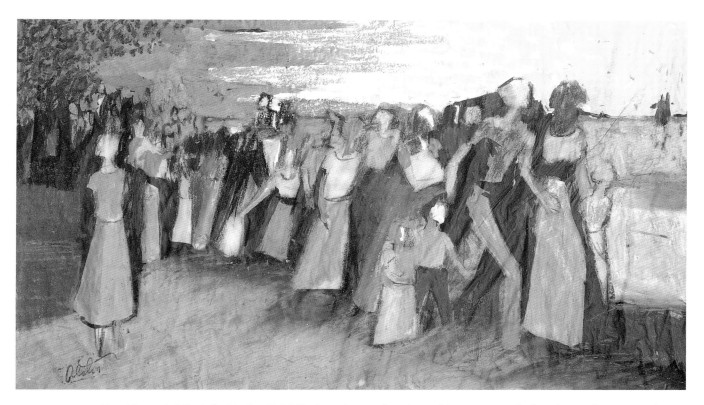

Plate 38. *Untitled (Study for "Walking")*, 1958. Gouache on vellum, 9 x 15 ³⁄₄ in. Courtesy of Bill Hodges Gallery, New York, NY.

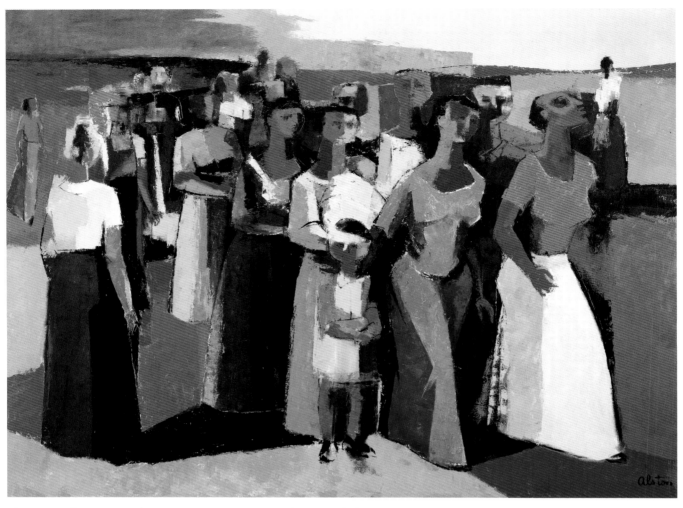

Plate 39. *Walking*, 1958. Oil on canvas, 48 x 64 in. National Museum of African American History and Culture, Smithsonian Institution.

CHAPTER THREE ENDNOTES

1. US National Archives and Records Administration, "Charles Alston, Artist and Teacher," http://arcweb.archives.gov. Images of over one hundred illustrations that Alston drew for the Office of War Information are available via this online archival research catalog.

2. Interview with Adele Logan Alexander, Washington, DC, August 28, 2005.

3. Center for Integrating Research and Learning at the National High Magnetic Field Laboratory, Florida State University Research Foundation, Inc., "Dr. Myra Logan," http://scienceu.fsu.edu/content/scienceyou/meetscience/logan.html. See also Oracle ThinkQuest Education Foundation, "Myra Adele Logan," http://library.thinkquest.org/20117/logan.html.

4. Ibid.

5. The Office of Minority Health, "Myra Adele Logan," http://www.omhrc.gov/templates/content.aspx?ID=4033.

6. Interview with Adele Logan Alexander.

7. Ibid.

8. Gylbert Coker, "Biological Chronology," in *Charles Alston: Artist and Teacher* (New York: Kenkeleba Gallery, 1990). p. 22.

9. Interview with Adele Logan Alexander.

10. Interview with George Ford, Brooklyn, New York, November 2005.

11. The Art Students League of New York, catalog of classes, 1957–1958.

12. Ibid.

13. Telephone interview with Jean Lacy, May 2006.

14. Art Students League catalog.

15. In the documentary *Family Name* by filmmaker Macky Alston, this painting may be seen displayed in the apartment of Alston's sisters Aida Bearden Winters and Rousmaniere Alston.

16. Paul Laurence Dunbar, "We Wear the Mask," *The Collected Poetry of Paul Laurence Dunbar,* ed. Joanne M. Braxton (Charlottesville: University Press of Virginia, 1993).

17. Charles Alston, "Oral History Interview with Charles Alston," interview by Al Murray, October 19, 1968, transcript, Smithsonian Archives of American Art.

18. Romare Bearden and Harry Henderson, *A History of African-American Artists: From 1792 to the Present* (New York: Pantheon, 1993), pp 266–268.

A MAN FOR ALL SEASONS

THE SIXTIES AND SPIRAL

During the 1960s, Charles Alston was influenced by the civil rights movement. The African American struggle for equality that reached its height during this period had a considerable impact on the art and life of Alston, as it did on many African American artists, intellectuals, and community leaders. Black artists and students in the North, removed geographically from the sit-ins in Greensboro and the marches in Selma, were looking for ways to participate meaningfully in this great surge of communal expression and organization among African Americans. In the summer of 1963, Woodruff, Romare Bearden, and Charles Alston joined with a number of other black artists working in New York to create an alliance that came to be called Spiral. Proposed by Woodruff, the name evoked the Archimedean spiral, a symbol of expansive positive energy and all-encompassing movement, "because, from a starting point, it moves outward embracing all directions, yet constantly upward."[1] The group also included artists Norman Lewis, James Yeargans, Emma Amos, Calvin Douglas, Perry Ferguson, Reginald Gammon, Alvin Hollingsworth, Felrath Hines, William Majors, Richard Mayhew, Earl Miller, and Merton Simpson. Spiral meetings were held at Bearden's studio on Canal Street; later, they rented a space at 147 Christopher Street. Their meetings and discussions addressed how black artists should relate to American society in a time of segregation.[2]

In describing the need for the development of Spiral, Alston recalled the days of the WPA art projects that required "a great deal of association with other artists." He said:

> And one of the reasons we formed the Spiral group was that we felt that this kind of thing had disappeared and there was a great need for it. Particularly among the black artists. We at least needed to get together and talk informally, exchange ideas and perhaps discover some mutuality of direction, or at least see if there was a common denominator anywhere. Maybe there wasn't. Because we had all kinds of people. We had people who painted hard-edge abstractions, sort of romantic landscapes and figures. All kinds of people were in it. We just felt that we needed to get together and discover whether we had things in common, and, if possible, work out some kind of general broad philosophy. And I think this kind of thing does help. There are all kinds of questions that come up.[3]

Plate 40. *Untitled*, 1957. Oil on Masonite, 24 x 24 in. Courtesy of Bill Hodges Gallery, New York, NY.

In a sense, Spiral was a 1960s version of 306 on a more intimate, professionally focused level. These artists, now well established in their careers, were still fighting to be included and represented in mainstream organizations. That they maintained a conscious sense of purpose as they matured is testimony to their determination and their awareness of the connections between the art world and the outside world. Specifically, these black artists sought to influence the dynamics of the New York art scene through their own interventions.

Alston was an intellectual activist. From his opposition to segregated exhibitions for African Americans to his refusal to categorize himself as either an abstractionist or a narrative painter, he was a multifaceted man who loved his people in no uncertain terms. A forum such as Spiral allowed him and his fellow artists to explore many aspects of their own definition of self. Just as Alston spoke about the activism of black students at Columbia in his 1968 interview with music historian Al Murray, so too did he discuss the progressive attitude of youths in the civil rights movement:

> Of course I believe in the integration principle. I think maybe it's because I'm of a generation that believed in that. I think it's the most realistic and the most desirable attitude. However, I do feel that there's nothing wrong with some emphasis on the nationalist aspects of this thing. Just in looking around seeing these kids, you know, with the natural hair; I like it. I like the thinking behind it, the affirmative quality of it, this is my hair and it's good.[4]

Figure 11. *Untitled,* c. 1960s. Ink on paper, 10 3/8 x 10 in. Courtesy of Bill Hodges Gallery, New York, NY.

As a group project, members of Spiral decided to develop an exhibition based on the colors black and white, representing a group response to the civil rights movement. Because of disagreements among members, Spiral did not ultimately present it as an officially sponsored project. Several group members nonetheless moved forward individually to produce works for the show.

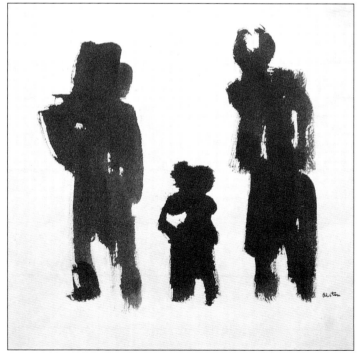

BLACK AND WHITE AND COLOR

As early as the late 1950s, Alston had already started to work in a deliberately limited black-and-white mode of expression. Until the mid-1960s, he created some of the most profoundly beautiful works of his career in this mode. His black-and-white explorations range from the lightly ephemeral to massive and brooding mental landscapes. In complete control of his medium, Alston appears to have enjoyed the immeasurable visual and emotional permutations of this black-and-white discourse.

In an untitled ink-on-paper drawing (Figure 11), a semirealistic scene presents two large figures with a smaller figure, a trio that might represent a family. On

second examination, the two larger figures could be wearing masquerade costumes and the third could be an animal. Like a Rorschach test, the drawing can be interpreted in different ways. A second black-and-white ink painting of a boxing match demonstrates Alston's ability to construct a dramatic scene with only a few firm brushstrokes. He succinctly conveys the energy between the two fighters: the sharp thrust of a left-handed punch is dodged by the bobbing and weaving of a crouching opponent. Outside the ring, Alston effectively characterizes the attentive crowd with mere blotches. The intuitive nature of this drawing speaks to Alston's talent as an illustrator and cartoonist: he could depict such narrative scenes with skillful economy.

Alston seems to be taking his time exploring the universe in an untitled oil-on-Masonite work of 1957 (Plate 40), a pure abstraction in black and white interspersed with earth tones. The rich patina of the surface, with its textured impasto, fuses the dark gray to black areas with cream and ochre tones to create a surface suggestive of cave interiors, with walls scorched by fires, or the mottled variations of color seen when looking into the endlessness of space with a high-powered telescope. In another oil-on-Masonite work completed in 1960 (Plate 41), Alston introduces a clay tone that provides the surface of the painting with geological references, suggesting the wet tonalities of an excavation. The beauty of the painting lies in the antiquity implied by the surfaces. The gorgeous mysteriousness of an abstract ink drawing on rice paper, completed in 1959 (Plate 42), also suggests the geological surface of another planet, rich in texture and depth of tone. In its textured acceptance of the ink, the thin rice paper creates an additional surface interest to the rich variations of gray and black in the work. The waves of the paper surface call to mind the surface of a mineral sliced away from its source.

In another ink drawing titled *Black Aborning* (Plate 43), Alston creates an area of dense blackness at the bottom of the rice paper out of which black shapes, suggestive of arms, reach up toward a series of crescents. The animation of the upper area emanates from a sense that figures of some kind are ascending out of the velvety blackness; they seem to be gathering together. The unmistakable rise of energy from the bottom of the page to the upper register of the work creates a vibrant yet mysterious scene that directly reflects the title of the painting. Because Alston deliberately left so many of his works in this black-and-white period untitled, the title chosen here suggests the importance he assigned to this particular piece.

In his monumental oil painting *Black and White #1* (Plate 44), Alston creates zones of color from gray to white to black that move across the picture plane with distinct authority. The black segments have the same energized feel as the upper elements of *Black Aborning*,

Figure 12. *Untitled*, c. 1960s. Ink on paper, 10 ⅜ x 10 in. Courtesy of Bill Hodges Gallery, New York, NY.

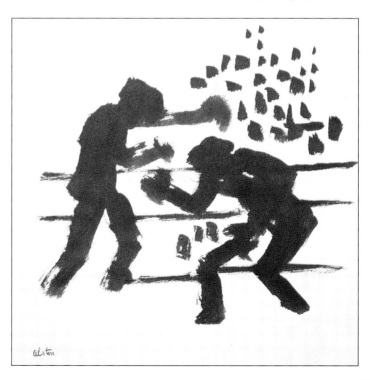

Plate 41. *Untitled*, 1960. Oil on Masonite, 7 1/4 x 15 1/2 in. Courtesy of Bill Hodges Gallery, New York, NY.

Plate 42. *Untitled*, 1959. Ink on rice paper, 17 x 13 ³/₄ in. Courtesy of Bill Hodges Gallery, New York, NY.

Plate 43. *Black Aborning*, 1959. Ink on rice paper, 16 x 12 in. Courtesy of Bill Hodges Gallery, New York, NY.

but the figurative references of the other work are abandoned for a completely abstract composition. Here, Alston creates huge wedges of black that collide with areas of gray and are silhouetted against a white background. Initially the painting might call to mind the black and white contrasts of Franz Kline. However Alston avoids the rawness and ferocity of Kline's brushstroke and the resulting stark contrast of his paintings. Alston instead moves toward a deliberate fusion of the black and white contrast, and he consequently imparts a solid field of energy to the gray midground. In contrast to the massive quality of *Black and White #1,* a delicate black-and-white ink drawing of 1960 (Plate 45) suggests an ephemeral seascape, with reeds growing at the shore, or perhaps a stark abstraction of figures moving across a horizon line. Yet another exploration of the expressive qualities of the colors black and white is seen in *Black and White #7* (Plate 46). In this painting Alston creates a representation of turbulence, primordial movement, and a suggestion of infinity that visually reflects the complexity of the universe.

Considering that such dramatic works became a source of personal focus for Alston in the early 1960s, when the world was reassessing itself in terms of race relations, the cold war, and nuclear arms, it is significant that Alston chose to satisfy his inner muse in the pursuit of very personal and inventive works.

Four additional works suggest Alston's other preoccupations within the black-and-white realm. Two of them fuse abstraction with a hint of human form. An untitled drawing made largely of vertical lines (Plate 47) suggests a convergence of forms that create an eerie landscape in the middle of a white void; on closer inspection, a face with deep-set eyes peers out from within this abstract landscape. In another (Plate 48), a face emerges from a gray background, with eyes loosely sketched in a quick and linear movement. The lower left corner of the painting is defined by a tumult of thick black brushstrokes, possibly suggesting a torso.

The other two compositions demonstrate Alston's interest in the loose abstraction of calligraphic forms. In one (Plate 49), he infuses black and gray tones into the paper, creating atmospheric areas which he then lightly embellishes with seemingly stray calligraphic markings; these come together at one point to create a grid form. In the other, a dynamic pen-and-ink on paper (Plate 50), Alston explores the immense potential of the horizontal white surface to evoke a visual power equal to the calligraphic movement of energized black streaks of ink, guiding one's eye across the picture plane toward the right.

The 1969 oil painting *Blastoff* (Plate 51) is a more literal expression of the abstract passages in several of the works from Alston's black-and-white series. This seemingly abstract work is as eloquently beautiful and mysterious as earlier works, and only after reading the title does one grasp the artist's reference to the white and red flames of a spaceship's blastoff. This interest in space exploration seems to have taken Alston to a different plateau in investigating his own interior mental landscape.

Taken together, the series of black-and-white works includes some of the most profoundly beautiful works of twentieth-century American art. But just as he created open-ended abstract compositions within the parameters of black and white, so too did Alston explore the potential of abstraction in color. An untitled oil from around 1960 (Plate 52) boldly sets down energized passages of indigo,

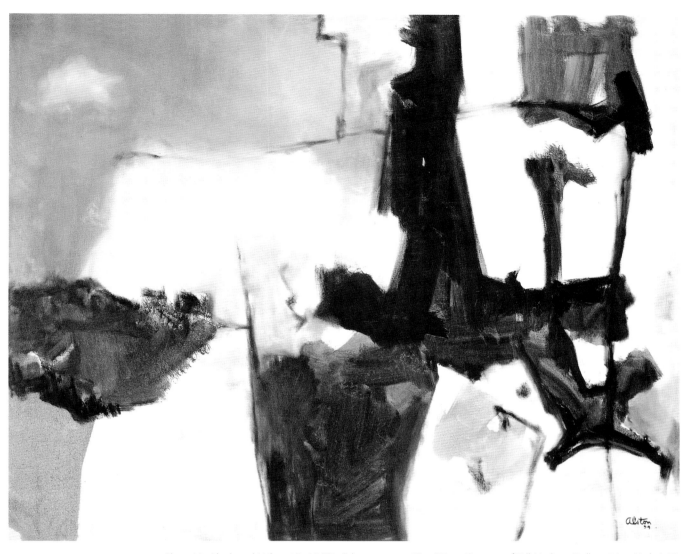

Plate 44. *Black and White #1*, 1959. Oil on canvas, 40 x 50 in. Courtesy of Bill Hodges Gallery, New York, NY.

Plate 45. *Untitled*, c.1960. Pen and ink on paper, 12 x 16 in. Courtesy of Bill Hodges Gallery, New York, NY.

Plate 46. *Black and White #7*, 1961. Oil on canvas, 45 x 54 in. Courtesy of Michael Rosenfeld Gallery LLC, New York, NY.

Plate 47. *Untitled*, 1959. Pen and ink on paper, 9 7/8 x 12 1/8 in. Courtesy of Bill Hodges Gallery, New York, NY.

Plate 48. *Untitled*, c. 1959. Pen and ink on rice paper, 16 x 12 in. Courtesy of Bill Hodges Gallery, New York, NY.

Plate 49. *Untitled*, 1960s. Pen and ink on rice paper, 10 3/8 x 10 in. Courtesy of Bill Hodges Gallery, New York, NY.

Plate 50. *Untitled*, 1960. Pen and ink on paper, 12 x 18 in. Courtesy of Bill Hodges Gallery, New York, NY.

Plate 51. *Blastoff*, 1969. Oil on canvas, 50 x 40 in. Courtesy of Bill Hodges Gallery, New York, NY.

yellow, black, and white, while a 1960 watercolor titled *Cliffside* (Plate 53) demonstrates the artist's ability to maintain a delicate balance between pure abstraction and ephemeral linear representation. Alston overlays zones of red-orange, yellow, and green with geometric linear designs: the end result is reminiscent of Paul Klee's work. Two other compositions of free calligraphic expression focus on combinations of red-orange and black ink. In one (Plate 54), a more linear use of the colors means that the paper's color fuses the delicate areas of soft red-orange, gray, and black, while in the other (Plate 55), large zones of red-orange are developed from broadly applied brushstrokes with an overlay of similarly broad applications of brown. The vibrancy of these compositions emanates from the free application of the design elements.

The politically charged atmosphere of the times certainly did not escape Alston. His 1960s works included images that dealt with race and the inequities of life in twentieth-century America. In 1960, he completed a portrait of Christ (Plate 56), one of the few religious works known to have been created by the artist. The painting, created in an angular, Modiglianiesque style, depicts Christ, with eyes lowered, draped in red and standing against the dark background of the cross. Approximately seven years later, Alston completed the stark and deliberately rough-hewn *You never really meant it, did you, Mr. Charlie?* (Plate 57). The composition of the painting calls to mind the earlier painting of Christ, while reflecting the frustration, anger, and ultimate disappointment of the time. A black man stands against a plinth of dark brown (similar to a crucifix), while a red-orange background burns around him. His face looks upward, cast in shadow, and his solitary form in the center of the starkly simple painting creates an undeniable statement of isolation and disappointment. Alston reflected on the times and this painting in particular:

> I think the whole thing that has happened today is that people have gotten to the
> point where they don't believe it any more, just like I just finished a picture and I
> don't usually go in for long titles or titles at all, but I'm just terribly tempted to call
> this picture (it's just a simple figure of a Negro man against a red sky looking as frus-
> trated as any individual can look) and almost just as intuitively as I looked at it I felt,
> "you never really meant it, did you, Mr. Charlie?"[5]

Later in the decade, Alston again embraced the human figure in *Confrontation* (Plate 58), a title appropriate for the time. The picture seems to be a sequel to *Walking*. Here the walking, the marching, has ceased, and the power of the group seems to have come to a standstill, to a demand that something be done about injustice.

For Charles Alston, it was important that the political statement of a work of art not mitigate its quality. The artist, first and foremost, had to be accomplished enough to interpret the great themes of struggle so prominent in the period without preaching. Alston, ever the teacher, felt that young artists of the 1960s often overextended themselves in an effort to create works that were "relevant to the cause":

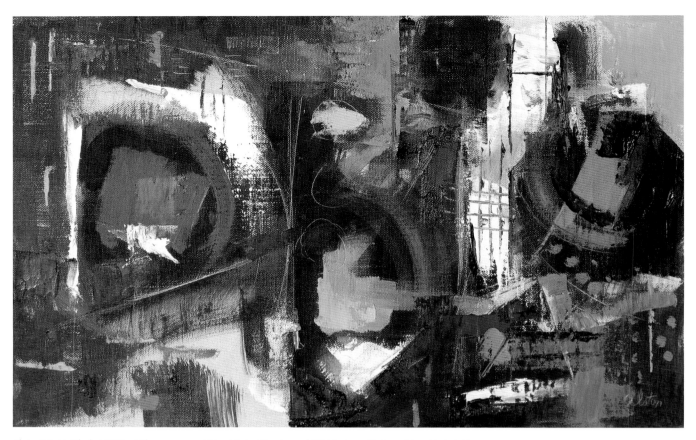

Plate 52. *Untitled*, 1960s. Oil on canvas, 10 x 16 in. Courtesy of Bill Hodges Gallery, New York, NY.

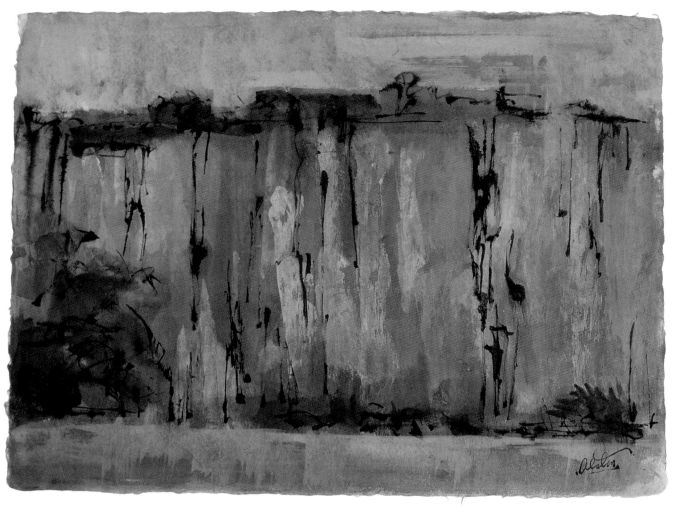

Plate 53. *Cliffside*, c. 1960. Gouache on paper, 12 x 15 $\frac{7}{8}$ in. Courtesy of Bill Hodges Gallery, New York, NY.

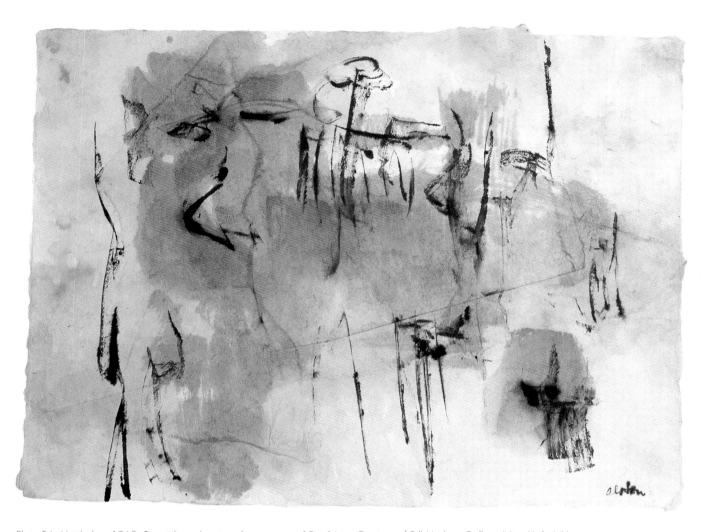

Plate 54. *Untitled,* c. 1960. Pen, ink, and watercolor on paper, 12 x 16 in. Courtesy of Bill Hodges Gallery, New York, NY.

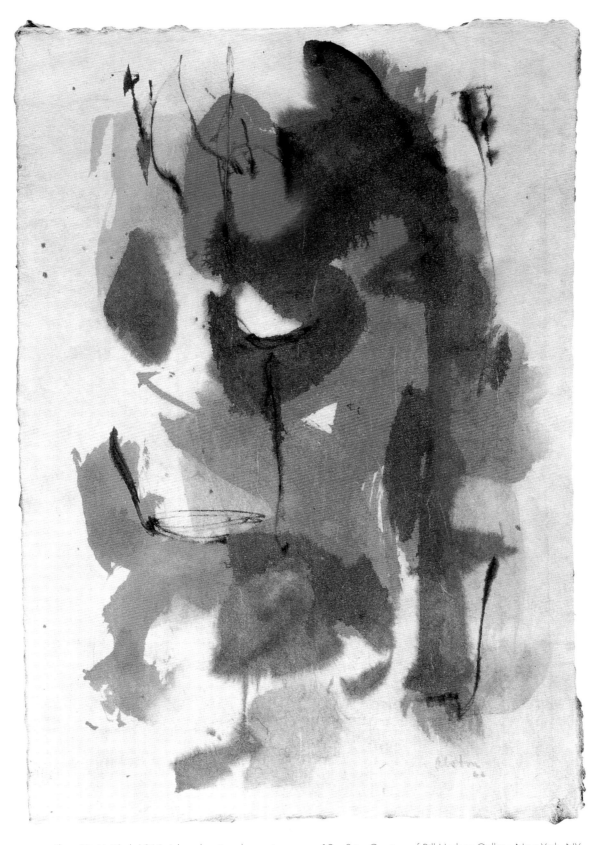

Plate 55. *Untitled*, 1966. Ink and watercolor on rice paper, 12 x 8 in. Courtesy of Bill Hodges Gallery, New York, NY.

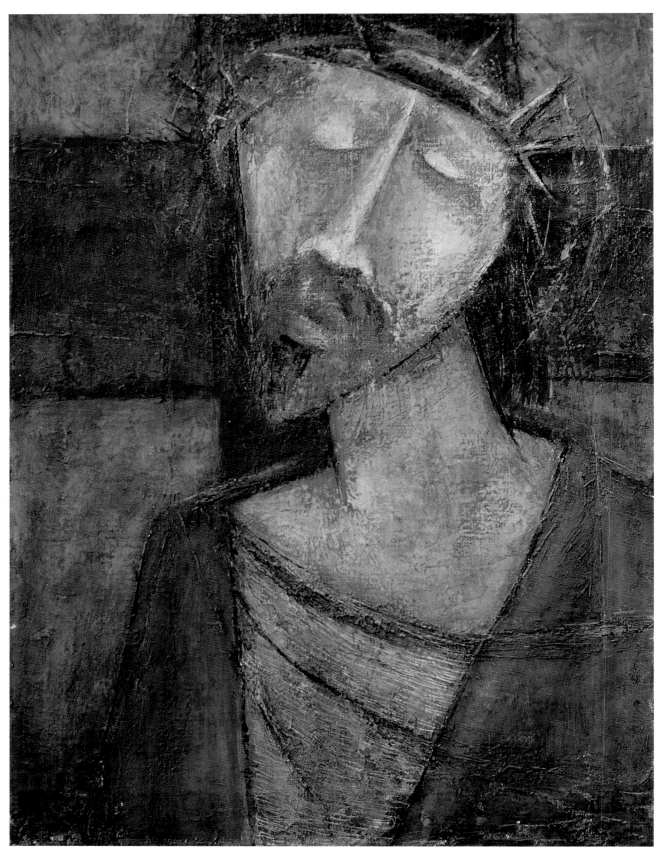

Plate 56. *Christ Head,* c. 1960. Oil on canvas, 24 x 18 in. Courtesy of Bill Hodges Gallery, New York, NY.

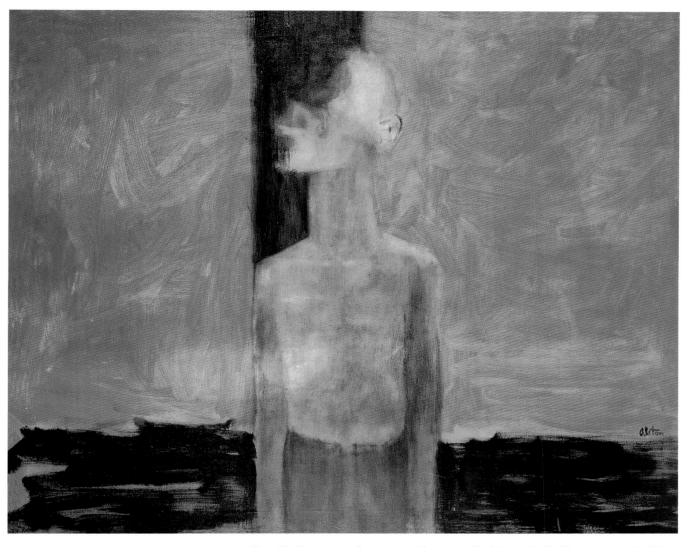

Plate 57. *You never really meant it, did you, Mr. Charlie?*, c. 1967. Oil on canvas, 40 x 50 in.

Courtesy of Michael Rosenfeld Gallery, LLC, New York, NY.

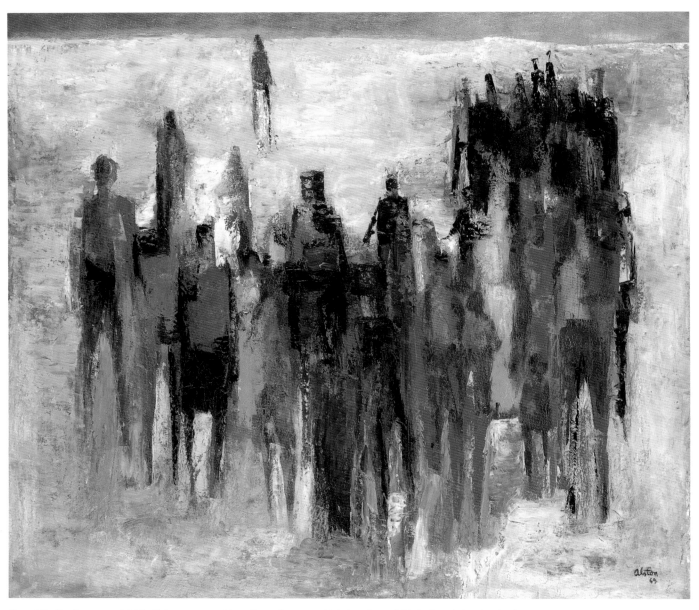

Plate 58. *Confrontation*, 1969. Oil on canvas, 36 x 40 in. Courtesy of Michael Rosenfeld Gallery, LLC, New York, NY.

I sometimes feel that what I see presented as black art is motivated much more by the political aspects of the situation than the art aspects. I think this is difficult to make clear. I think it's perfectly all right to use art politically. It's been done. It's been done beautifully by Daumier, Goya. But always behind this was a thorough and solid background in the aesthetic aspects of the art. It's after the mastery of the elements of painting or printmaking that you can speak out politically with great authority because you have such mastery of the tools involved. . . . Maybe what I'm saying is that I think there is a great anxiousness to make a statement before you're equipped to make the statement in that particular medium.[6]

Until the end of his life, Charles Alston continued to teach and to paint. In all his artworks, he sought to find forms of expression that felt right to him. Never concerned with what the critics were saying about his work as he moved from one style to another, and one medium to another, Alston continued to expand his artistic horizons. A decade before his death he commented on his relationship with the critics:

I remember [Emily] Genauer said once about an exhibition I had, she reviewed it and one of the remarks (I don't know whether she meant it as criticism or not but I always thought it hit it right on the head as far as I was concerned) she said "Alston refused to be pigeonholed." And that's been true. I mean I do a series of abstract paintings concurrently with a series of figurative paintings. I'll do very realistic things—I don't mean academically realistic things—and very far out avant garde things. And I don't stay too long with one of them if I can see the logical conclusion of it. . . . I want to explore different and new unknown territory.[7]

A TIME FOR ACCOLADES

During the last two decades of his life, Alston's labors as an artist and an educator led to numerous awards. The artist continued to teach at the Art Students League until 1971. In 1968 he received a presidential appointment from Lyndon Johnson to the National Council on the Arts. That same year he had a solo exhibition at Fairleigh Dickinson University in New Jersey, with an accompanying catalog, and in 1969 he was given a one-man exhibition at the famous Huntington Hartford Gallery of Modern Art (soon to become a new art center in New York City) south of Central Park. At this exhibition, author Lemoine Pierce met Alston; she

Figure 13. Alston at the reception for his exhibition at the Huntington Hartford Gallery of Modern Art. Photograph courtesy of Aida Bearden Winters.

soon began collecting his work and documenting his life. In 1973, Alston was made a full professor at City College, where he had taught since 1968. And in 1975, he was awarded the first annual Distinguished Alumni Award from Teachers College at Columbia University. During the same year he exhibited in the "Hundredth Anniversary Exhibition of Paintings and Sculpture" at the Art Students League. While some African American artists were beginning to look seriously toward Africa for inspiration, Alston continued to excavate the endless possibilities of creativity inherent in Manhattan.

As Alston achieved greater acclaim downtown with the mainstream art community, so too did his wife expand her professional horizons in a number of ways. In the 1960s, Myra Logan began conducting research on breast cancer. She developed a more accurate X-ray process that could detect differences in the density of tissue and discover tumors sooner. She was passionately committed to social issues and was a member of the New York State Committee on Discrimination as well as the NAACP. After her retirement in 1970, she served on the New York State Workmen's Compensation Board. As a result of her contributions to modern medicine and society, she was elected to the American College of Surgeons.

This couple, united for life, enriched the lives of so many others while providing unconditional love and support for each another. In January 1977, Myra Logan died. Only a few months later, on April 27, 1977, Charles Alston passed away after a long bout with cancer. At his memorial service, his friend George Gregory delivered the eulogy, in which he stated in part:

> [He] emerged from all the changes, travels, experiences and honors as a man for all seasons: genteel and friendly, wise and with the power of perception—to see and feel things, people, his surroundings. Added to perception and understanding, he lived his life by that Arista motto of character, service, and excellence.[8]

CHAPTER FOUR ENDNOTES

1. Myron Schwartzman, *Romare Bearden: His Life and Art* (New York: Harry N. Abrams, Inc., 1990), p. 209.
2. Ibid.
3. Charles Alston, "Oral History Interview with Charles Alston," interview by Al Murray, October 19, 1968, transcript, Smithsonian Archives of American Art.
4. Ibid.
5. Ibid.
6. Ibid.
7. Ibid.
8. Gylbert Coker, "Biological Chronology," *Charles Alston: Artist and Teacher* (New York: Kenkeleba Gallery, 1990). p. 26.

An Enduring Narrative

*T*he legacy of Charles Alston survives in the fabric of New York cultural life and beyond. In addition to the countless students he taught and the organizations he fostered, Alston created a group of public artworks that continue to enrich the urban landscape of New York City, and indeed a twenty-first-century America. From the Harlem Hospital murals to the murals for the Federal court building, Alston used his art in a public manner to educate and inspire. From his own inner explorations, he left behind a body of paintings, drawings, and sculptures that continue to intrigue scholars and collectors alike. The process of learning about African American art in the twentieth century has been an ever-evolving one for the general public, and it is becoming more clear that Alston, in his friendships and collaborations with other artists—including Romare Bearden, Robert Blackburn, Jacob Lawrence, and Hale Woodruff—established a network of creativity that continues long after him. A narrative of African American culture and self-reliance is firmly attached to the name Charles Henry Alston.

Figure 14. Charles Alston, June 18, 1976. Photograph courtesy of Dr. Regenia A. Perry.

Witness to many of the major chapters of twentieth-century American history, he viewed his evolution as an artist as a serious undertaking. He moved from the early days of the Harlem Renaissance, a period of social realism and Afrocentric discovery of cultural history, to a postwar period of personal exploration and expansion of his own boundaries. His personal encounters with artists such as Aaron Douglas, Diego Rivera, and Stuart Davis led Alston to pursue his own definition of style.

A portrait artist of great accomplishment, Alston often used more stylized versions of the human form in his determination to bring a different expressiveness to his paintings and drawings. In his explorations, he continued to push himself to create with an open-ended freedom, not to be "pigeon-holed." His ambitious productivity led critics to write things like, "Charles Alston restlessly experimented in figurative modes over his long career," or, "His restless need for expression caused him to work in many different styles with the result that he never evolved a readily identifiable personal style." Rarely is Picasso criticized for his ventures into ceramics, mural painting, or bronze casting. He is thoroughly forgiven for his many diversions, from realistic early forms to his later highly abstracted paintings of women, to his sparely defined drawings. These styles are embraced and acknowledged by critics as an obvious indication of Picasso's complexity. Why then is it so difficult to regard Alston in the same light? The fact that he could create the Golden State Mutual murals and delve into a series of abstract easel paintings during

the same period indicates an unbounded intellect and an immensely creative spirit. There are several subsets of Alston the artist: he is the history painter creating epic images in his early murals; he is the cartoonist showing his skill as a draftsman and comedian; he is the pure abstractionist dealing with his own inner explorations; he is the artist who focuses on the power of his people through the symbolism of the black family.

When one looks at the many organizations that Alston has been associated with, it becomes clear that he strove throughout his life to achieve a balance between his time at the easel and his time spent working with others to foster change from within the African American community.

Decades after his death, the good fight fought over the Harlem Hospital murals has reached a poetic conclusion, as the murals have come to be recognized by the city as national treasures. Almost seventy years after their creation, the cultural significance of the murals was publicly recognized and the controversy surrounding their completion revisited when the hospital announced that the murals would be saved from the scheduled demolition of the buildings that house them. Along with Alston's two murals, three others—Vertis Hayes' eight paneled *Pursuit of Happiness,* Georgette Seabrooke's *Recreation in Harlem,* and Alfred Crimi's *Modern Surgery and Anesthesia*—will be removed during the hospital's renovation and returned to a new site after their restoration.

Charles Alston moved between the island of Manhattan and the rest of the country—and Europe—traveling west to California to examine blacks' contributions to the settling of the American frontier, traveling south to examine the early roots of his people, but always returning to New York to meditate on the intricacies of the many worlds around him. He emerged as a seasoned, committed artist for whom the pulse of the city was an inspiration. Alston was in many ways a bridge for a younger generation, a pioneer who ventured fearlessly into the foreign territory of mainstream art, all the while gathering information for those who followed him. His generosity was evident, and his career-long desire to teach reflected his determination to change the art world from the inside. He was always aware that there might be another Jacob Lawrence waiting to be taught.

Following the major 1990 retrospective "Charles Alston: Artist and Teacher," organized by the Kenkeleba Gallery and curated by Gylbert Garvin Coker, interest in the oeuvre of Alston resurged. In 1997, the exhibition "Rhapsodies in Black: Art of the Harlem Renaissance" toured the country, and brought to light Alston's key role as both an artist and an arts advocate during the Harlem Renaissance. In 2000, a bronze bust of Dr. Martin Luther King Jr., created by Alston in 1970, became the first image of an African American displayed at the White House.

Alston left a body of work that has yet to be fully considered. In learning more about his accomplishments, we will learn more about the strata of the twentieth-century art world. This man who taught Robert Blackburn, Romare Bearden, and Jacob Lawrence was a man of immense talent and vision. Alston was a trailblazer, and in the midst of his own very secure life and very defined personal place, he preserved the soul of an artist, searching out unique scenes of city life, seeking inspiration, going to shows, meeting other artists and intellectuals—such as Alain Locke and Diego Rivera (with whom he used to converse in French!). He was a man on the move, not one to simply settle, possessed of a curiosity that drew him to Picasso's *Guernica* on one hand and Bessie Smith's blues on the other.

The fact that Alston chose not to continue with commercial work, for which he had such a facility, indicates the depth of his resolve to pursue fine art. His complaint later in life that teaching intruded on his concentration—hence his decision never to teach a full load of classes—strongly suggests his determination to make an original statement, to create something that was completely Alston. A lifelong challenge for Alston was to give his all in the classroom only to return to his studio and face the difficulty of replenishing his own creativity. (He once said that an artist, to be fully creative, should have a job completely apart from his art, something that would be almost mindless, to prevent his creative juices from seeping away.) But it was the competitive environment of New York, the galleries, the museums, and his fellow artists that enabled Alston to keep his edge.

For African American artists of the twentieth century, reaching the end of one's career can be an intensely challenging and conflicted moment. As one examines the production of a lifetime and compares it to the recognition received—especially in comparison to accolades received by other artists—it can be hard not to become discouraged or, even worse, embittered. Some great African American artists, such as Nancy Elizabeth Prophet, completely stopped working near the end of their lives for lack of recognition and destroyed much of what they had created.

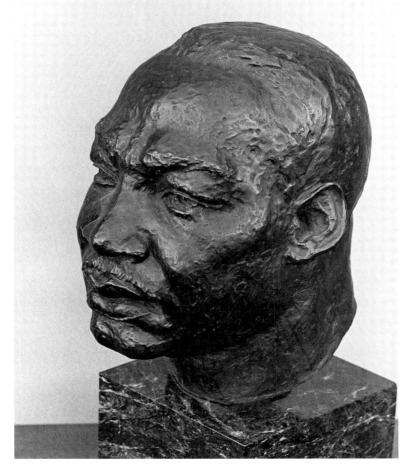

Figure 15. Alston's bust of Martin Luther King Jr. Photograph courtesy of Aida Bearden Winters.

Charles Alston did not stop working. Ultimately, for him, life and art were not separate. As artist Joe Overstreet stated, "He was a very gregarious person. He laughed and told stories. Freedom was night life and having a good time. His art was the same way. . . . He wanted to be alive. He was a versatile artist." The same freedom that he found with his friends in the entertainment world, and with his family in a home filled with discussion, music, and great food, he found at the easel, or carving wood, or on a scaffold creating a mural. One experience inspired the other. Life was 306 lived fully each day. He was always focused on his open-ended journey to visual discovery. Versatility for Alston was neither a weakness nor an indication of a lack of focus. On the contrary, versatility meant living life as an artist as he did as a man, at full throttle, always testing the boundaries of his purpose for being, always pursuing the new image, the new visual idea. His critics simply didn't keep up with him. Simplifying his artistic production into a "readily identifiable style" was not his concern. For Alston the artist, each work was readily identifiable and sprang forth from a vigorous place in his imagination. Each work reflected his constant demand on himself to bring the best

technique and skills to his art, in a never-ending quest for freedom of expression—Alston's ultimate freedom.

Alston's life plan was simple. He felt that he should create as much as he could while continuously defining himself as an artist. In the catalog from the 1972 exhibition of Alston's work at Atlanta University Center, Alston presents his artistic philosophy in his own words:

> This ambivalence of involvement is the unique predicament of the black artist in America today. It is, for that matter, the predicament of any artist, black or white, who is concerned with the dignity of man. It is the Ivory Tower and the "Nitty Gritty." Art is the pursuit of truth as the artist perceives it. *Guernica* shows us that it can also be a powerful and effective weapon in the struggle for human decency.

Thus the man born on Thanksgiving Day, 1907, spent his life as an artist on a directed journey, always blazing new paths in the pursuit of truth as he perceived it.

Figure 16. Charles Alston with students, date unknown. Photograph courtesy of Aida Bearden Winters.

CHARLES ALSTON CHRONOLOGY

1907 Born November 28 in Charlotte, North Carolina, to Reverend Primus Priss Alston and Anna Elizabeth Miller Alston. His father nicknames him "Spinky."

1910 Death of Reverend Primus Priss Alston.

1913 Anna Alston marries Harry Bearden, uncle of artist Romare Bearden.

c. 1915 Family moves to the Harlem neighborhood of New York City. The children return regularly to North Carolina to spend summers with relatives.

1922–1925 Attends DeWitt Clinton High School.

1925–1929 Attends Columbia University; receives bachelor of arts degree.

1929 Receives Arthur Wesley Dow Fellowship, enabling him to continue his education at Columbia.

c. 1929–1930 Works as a director at the Utopia Children's House. One of his students is young Jacob Lawrence, with whom he begins a mentoring relationship.

1931 Receives master of arts degree from Teachers College, Columbia University.

1934 With Henry Bannarn, establishes the WPA Harlem Art Workshop at 306 West 141st Street. Known simply as 306, the building becomes a gathering place for Harlem artists, musicians, and intellectuals.

 His work first appears in major museums as part of a traveling group exhibition sponsored by the Harmon Foundation.

 An Alston illustration appears in the October 6 issue of the *New Yorker*.

1935 Becomes the first black supervisor of the WPA Federal Art Project, with a commission to oversee the completion of the Harlem Hospital murals, two of which he will create himself.

 Founding member, Harlem Artists' Guild.

 Formal protest against hospital administrators' rejection of Harlem Hospital murals organized by Harlem Artists' Guild and Artists' Union. After a series of press articles and meetings, artists are permitted to proceed with project.

1936 His two murals *Magic in Medicine* and *Modern Medicine* are exhibited at the Museum of Modern Art before their installation at Harlem Hospital.

1938 Receives a Rosenwald Fellowship and uses the money to tour the South with Giles Hubert of the Farm Security Administration.

1940 Receives a second Rosenwald Fellowship and spends time with Hale Woodruff at Atlanta University.

1940–1944 Hired as a staff artist for the Office of War Information and Public Relations; produces a series of illustrations about African American achievements. After the United States enters the war, he creates cartoons and posters that promote the government's war efforts.

1942–1944	Serves in the United States Army.
1943	Board of Directors, National Society of Mural Painters.
1944	Marries Myra Logan, a surgeon at Harlem Hospital.
1944–1945	Studies at Pratt Institute in Brooklyn.
1949	With Hale Woodruff, completes a major mural project for the Golden State Mutual Life Insurance Company's headquarters in Los Angeles: the two-paneled *Negro in California History*.
1950	Becomes the first African American instructor at the Art Students League, where he will continue to teach until 1971.
	The Metropolitan Museum of Art purchases one of Alston's abstract oil paintings, which he had entered in the competitive exhibition "American Painting Today," among thousands of other entrants. The prestigious purchase award validates his decision to cease working in the field of commercial art.
1953	First major solo exhibition, John Heller Gallery, New York.
1956–1957	Teaches at the Museum of Modern Art, becoming its first African American instructor.
1957–1958	Travels to Belgium, with sponsorship from the Museum of Modern Art and the State Department, to help coordinate a children's creative center at the Brussels World's Fair.
1958	Receives a National Institute of Arts and Letters grant.
	Member, American Academy of Arts and Letters.
1963	Founding member, Spiral.
1968	Receives a presidential appointment to the National Council on the Arts.
1968	Solo exhibition, Fairleigh Dickinson University, New Jersey.
1969	Solo exhibition, Huntington Hartford Gallery of Modern Art, New York.
1972	Exhibition, Atlanta University.
1973	Named a full professor at City College of New York, where he has taught since 1968 and will continue to teach until his death.
	Commissioned to create two mosaic murals for the Bronx County Family and Criminal Court Buildings. Murals completed in 1975.
1975	Receives the first annual Distinguished Alumni Award from Teachers College, Columbia University.
1977	Wife, Myra Logan Alston, dies in January. Charles Alston dies of cancer on April 27.
1990	Major retrospective exhibition, "Charles Alston, Artist and Teacher," Kenkeleba Gallery, New York.
1997–1998	The traveling exhibition "Rhapsodies in Black: Art of the Harlem Renaissance" includes an overview of his career.
2000	Alston's 1970 bronze bust of Martin Luther King Jr. becomes the first image of an African American ever put on public display in the White House. The work is in the permanent collection of the National Portrait Gallery, Smithsonian.
2005	Harlem Hospital administrators announce a two-million-dollar plan to save and restore Alston's two murals, *Magic and Medicine* and *Modern Medicine,* and three others during a major renovation.

INDEX